Motoring Around

KENT

The First Fifty Years

Motoring Around
KENT
The First Fifty Years

TIM HARDING & BRYAN GOODMAN

AMBERLEY

First published 2009

Amberley Publishing Plc
Cirencester Road, Chalford,
Stroud, Gloucestershire, GL6 8PE

www.amberleybooks.com

British Library Cataloguing in Publication Data.
A catalogue record for this book is available from the British Library.

ISBN 978 1 84868 575 8

Typesetting and Origination by Diagraf (www.diagraf.net)
Printed in Great Britain

Contents

The Authors

Tim Harding is 68 and retired: he had a career as a marine underwriter at Lloyd's, and later as director of a charitable Trust. His fascination with the motor car dates back to childhood, and his collection currently ranges from a 1923 Belsize-Bradshaw to a 1953 Frazer Nash.

Bryan Goodman (75) also had a past career in the City as a chartered surveyor, leaving at the age of 39 to become a property entrepreneur. He also has an adult life interest in early motor cars now with 1900 Benz, 1913 Sunbeam and 1926 Amilcar Italiana.

Both authors are avid collector of early motoring photographs, and this volume gives them a chance to share some of those images.

Introduction

For motoring historians it is fortuitous that the camera was well established by the time the car arrived on the scene. Thus the whole span of its history is well documented and its formative years, up to say 1914, were generally recorded by plate cameras, producing images unrivalled today for clarity.

This book seeks to use photographs to delineate both the development of motor transport, and its impact on the Kentish landscape. During the period covered, up to the Second Word War, the car progressed from being an unreliable plaything for a few real enthusiasts, to a practical means of transport for the man in the street. In so doing it inevitably became more boring and less individualistic, and for this reason there is a disproportionate emphasis on earlier vehicles.

To set the car in context, photos are also included of street scenes, car parks, garages and special events, all of which show clearly how motor transport had far-reaching effects on the environment, by no means all beneficial.

Kent embraced the motor car very early on, and the first ever exhibition of cars in this country was held at Tunbridge Wells on Tuesday, 15 October, 1895. It was organised by Sir David Salomons, M.P., who lived at Broomhill Close, Tunbridge Wells.

The county was not a great centre for motoring competitions, though in the period when public roads were used for this purpose, prior to 1925, hill climbs and sprints were held at venues such as Westerham Hill, Toys Hill, Cudham Hill, Herne Bay and Detling. However the spread of motoring was particularly fast in Kent: by January 1914 11,000 vehicles (including motor-cycles and steam engines) had been registered in the county, plus an unknown number more in Canterbury, which as a County Borough, issued its own registration marks (It should be made clear that for the purposes of this book we are using the county boundary which pertained prior to the creation of the GLC).

Kent has not spawned any well-known makes of motor car: marques such as Orpington, Westcar, Canterbury and Dewcar came and went (usually very quickly) without leaving any lasting impression on the motoring scene. Worthy of special mention are the Arnold, a Benz look-alike made in small numbers in East Peckham from 1896 to 1898, and thus one of the earliest British makes, and the Pearson-Cox, a rare example of a British-made steam car of which a few

were built at Shortlands, near Bromley. Similarly there were no motorcycles of real significance built within the county.

Commercial vehicles were a different matter for there were two successful Kentish manufacturers: J&E Hall of Dartford built the Hallford lorry from 1907 to 1925, and Tilling-Stevens of Maidstone made a considerable number of bus chassis, and rather fewer commercials, including their famous petrol-electric model, in which the engine worked a generator, which in turn powered an electric motor, which drove the back axle via a conventional prop shaft.

Finally there were two firms building steam lorries: the short-lived Jesse Ellis Company in Maidstone, and the much more significant and long-lasting Aveling & Porter at Strood. The latter name is of course much more familiar in connection with steam rollers, lorries only constituting a small part of their production. Aveling & Porter products, each bearing the Invicta symbol of a prancing horse, were sold worldwide, and they were the most prolific producers of steam rollers.

For much of the period covered by this book the bespoke coachbuilder played an important role, for many cars, especially the more expensive ones, were supplied as chassis, and bodied to the owner's requirements. Almost every town would have had at least one coachbuilder in the period before World War One, who had usually transferred his skills from horse-drawn vehicles to the new fangled horseless carriages. Kent had many such enterprises, among the best-known being Hely of Sevenoaks, Maltby of Sandgate, Beadle of Dartford, Bligh of Canterbury, Short of Rochester, Crips of Sidcup and Rock Thorpe and Watson of Tunbridge Wells. Two names were particularly important: James Young of Bromley bodied the most luxurious makes such as Rolls-Royce, Bentley and Sunbeam, and outlived almost all their rivals by surviving to 1967; and Martin Walter of Folkestone produced attractive bodies, often drop-head coupes, on a number of chassis, and survived World War Two to specialise in their well-known Dormobiles.

It may be of interest to know that the Kent registration records have survived virtually intact, up to the date when the DVLA became responsible for issuing new numbers. They are accessible to the public at the Centre for Kentish Studies, County Hall, Maidstone. Unfortunately from 1921 onward the details recorded are minimal, but prior to that date the registers form a fascinating picture of who owned what. Sadly the equivalent records for Canterbury C.B.C. do not survive.

The Kent two letter registration marks are as follows (in the order in which they were issued): D, KT, KN, KE, KK, KL, KM, KO, KP, KR and KJ. The Canterbury marks are FN and JG.

It is the hope of the authors that the majority of the images reproduced in this book will be previously unseen by its readers and provide an overview of what motoring was like in the county in the period up to 1945.

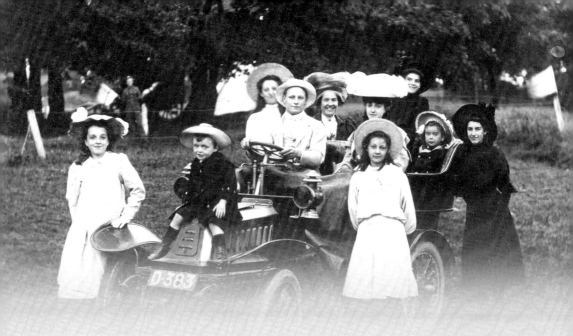

Chapter 1
Veteran and Edwardian cars

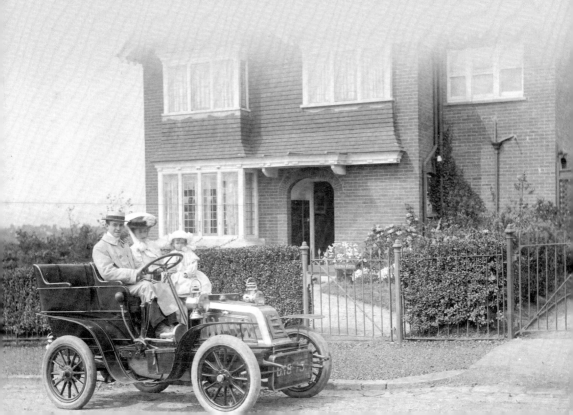

The very first issue of the – still current – magazine, *The Autocar* was on 2 November 1895. It gave three pages of coverage to The Horseless Carriage Exhibition organised by Sir David Salomons, the Mayor of Tunbridge Wells. Driving a horseless carriage on the highway was still illegal without a man walking in front, so even the assembling of a tangible proportion of the cars existing in the south east of England must have been very difficult. In the event four of the six exhibits listed appeared.

Nos 1 and 6 were four-seated vehicles with rear-mounted German Daimler engines and chain-driven.

No.2 was an old Daimler converted to be an estate fire engine, with the engine as the power for the water pump.

No.3 was a De Dion Bouton brought from France by Monsieur Bouton and described as having its engine neatly and unobtrusively enclosed. It did not perform well on the rough grass.

No.4 was a De Dion Bouton steam tractor pulling a horse-drawn Victoria with the front axle pivot mounted on the tractor tail.

No.5 was a Gladiator tricycle that did not appear.

At the end of the afternoon "Sir David evidently steeled himself to dare the majesty of the law, as he led the other cars on to the road to Tunbridge Wells where the cars proceeded faster and more smoothly and in perfect control to the pleasure of the many spectators and no disturbance at all to the horses". *The Autocar* article concluded "the hour of the motor driven road vehicle is close at hand".

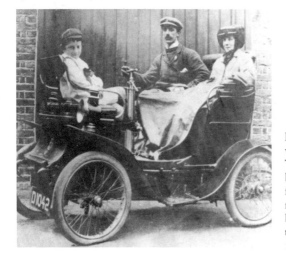

DE DION BOUTON had been making steam vehicles and then tricycles since 1883. This 4 ½ h.p. vis-à-vis dates from 1899/1900 but was registered on 1 January 1904 from which date all vehicles had to carry a registration number. The car was registered by W.T. Tarry of High Street, Bromley, but this photo is captioned "The Perkins Family 1905".

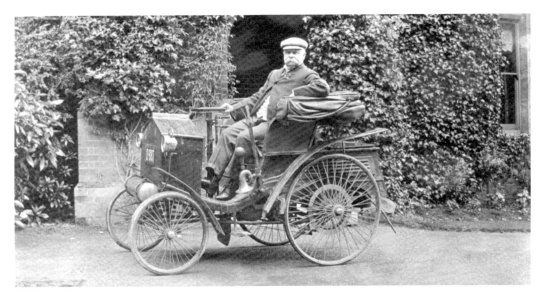

Above and below: Raymond de Barri Crawshay of Rosefield, Sevenoaks, bought this, his first car, from A.A. Whitehead of Sevenoaks in June 1907. The car, a 3½ h.p. BENZ, here seen with his father at the wheel, was then already eight years old and very out of date at a time when advances in motor car design were at their most rapid ever. A sixty-year-old car today would feel less unfamiliar.

One author has had a similar Benz for over fifty years. It not only has a wooden chassis and wings, solid tyres and tiller steering but also a separate lever for each of its three forward gears and a top speed of only 17mph.

The pitched roofed compartment in front of the driver must be a luggage locker: it is not part of the original car. The registration D 887 would have been issued in January 1904 when all cars on the road had to have numbers.

The de Barri Crawshay family appear again in this book with a 1904 Oldsmobile and a 1908 Straker Squire.

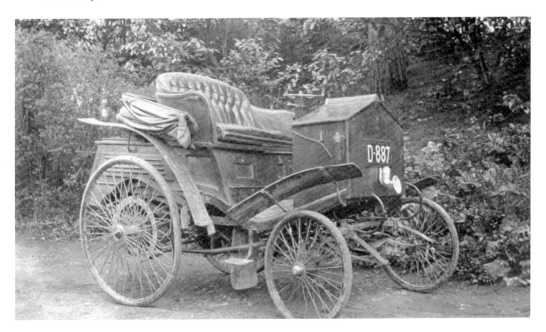

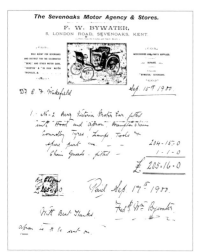

One of the authors bought the BENZ VICTORIA motor car, for which this is the original receipt, in 1957. He still has it – fifty-two years and fifty London to Brighton Runs later. The original owner, Dr Wakefield of Norwood Hill, near Reigate in Surrey must have driven the car home from 5 London Road, Sevenoaks, in September 1900, perhaps having never driven or even been in a car before.

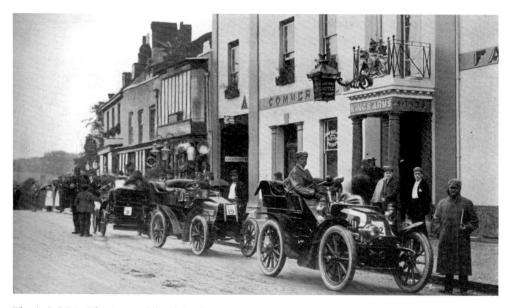

The A.C.G.B.I. (The Automobile Club of Great Britain and Ireland, later to be the R.A.C.) held a 650 miles Reliability of Motor Vehicles Trial in September/October 1902. The cars are shown in Westerham.

The running order was drawn each day and a 12mph average speed imposed so that each day's run was extremely tedious for the drivers of the faster cars who were forbidden to overtake by the travelling "observers".

This is what one of those "observers" reported about police traps:

"The competitors were dogged from day to day by the police. In Surrey and Sussex alike, though not, I believe, in Kent, there were traps innumerable. At one place on the Brighton road the police actually employed a furniture van in which to hide; while the Caterham Valley on Saturday afternoon was a perfect hotbed of spies in hedgerows and ditches, who, with calculated meanness, selected for their "timing" a moderate gradient on which there was no necessity to use the brake, but down which the competitors, even in a reliability trial, might let the cars descend by gravity at a somewhat faster rate than usual. It is impossible for any fair-minded man to describe as aught but monstrous these highwaymen tactics, directed against the participants in a public trial, of which the whole object was to establish the utility of the motor vehicle by strictly legitimate means."

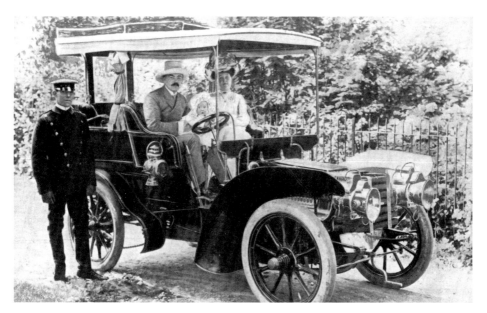

"The Youngest Lady Automobilist". She is Miss Hordern, aged nine months, of The Orchard, Shortlands. She is in an M.M.C. (Motor Manufacturing Company, Coventry).

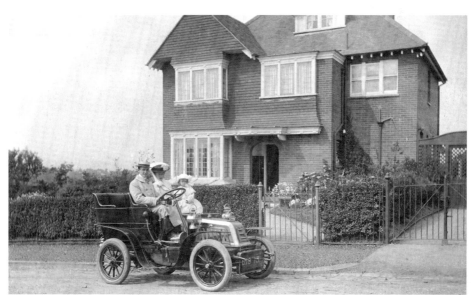

One can imagine the scene in 1905. New car, new house, new daughter and a professional photographer with his tripod-mounted plate camera to take the picture. The house is "Buena Vista", Sevenoaks, and has a side driveway, which must have been very rare at the time. The road is unmade. If the house still stands it is surely now immersed in a tight residential area of Sevenoaks. The car is a 1903 CLEMENT-TALBOT 7/8h.p., red-painted, four-seat tonneau (which means rear entrance) registered to Percy Potter of Sevenoaks in April 1905. Why it has a spring 1905 registration one can only guess but it could have been recently imported from France or, more likely, have been bought second-hand, the first owner keeping its previous registration.

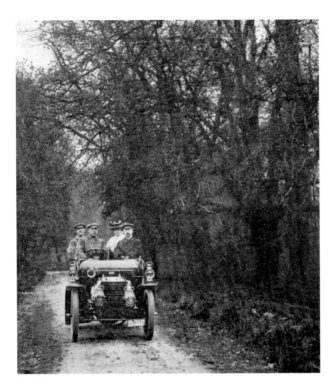

These pages: These pictures show a 1902 DAIMLER 14h.p. and 1904 DE DION BOUTON single cylinder of 6h.p. belonging to Mr and Mrs George Sutton of Home Lodge, Beckenham. The article on the opposite page appeared in *The Car* magazine in January 1905.

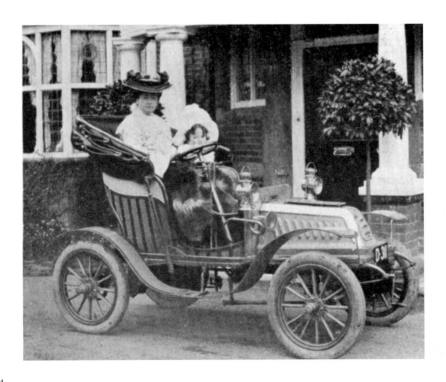

Mr. Sutton now owns a 14 h.p. Daimler and a 6 h.p. De Dion. The latter is driven by Mrs. Sutton, who is an ardent motorist, and has driven her car almost daily for ten months without any but ignition troubles, and those very few. During this time the car has never needed the services of a skilled mechanic, and has proved itself thoroughly reliable.

Home Lodge lies near Beckenham in a beautiful district close to the borders of Kent. Its position is most convenient for a motorist as there is ready communication with many of the most delightful regions in the south of England, and Mr. Sutton takes full advantage of this, although he is a very busy man. In fact his motorcar enables him to obtain more leisure, as he can economise much time in getting to and from business. Mrs. Sutton is also a most accomplished motorist and drives her De Dion with remarkable skill.

At Home Lodge there is a large and well-equipped *garage*, and every provision is made for the thorough overhaul of the cars, as Mr. Sutton is a strong believer in having his automobiles in perfect trim before taking them out.

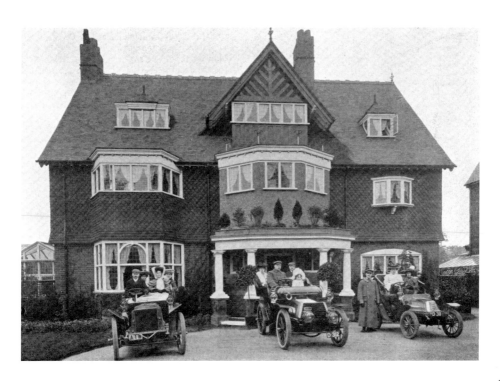

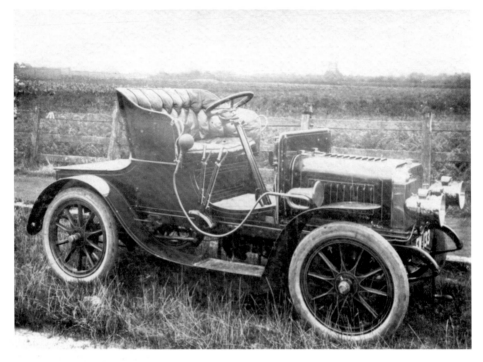

Above and below: Made in Coventry the SWIFT make lasted from 1901 to 1931. These examples are from 1904 but show the lack of factory standardisation at that time. The bulb horns might have been the customers' purchases but while both have side quadrant gear-change the smaller car has a completely separate handbrake arrangement.

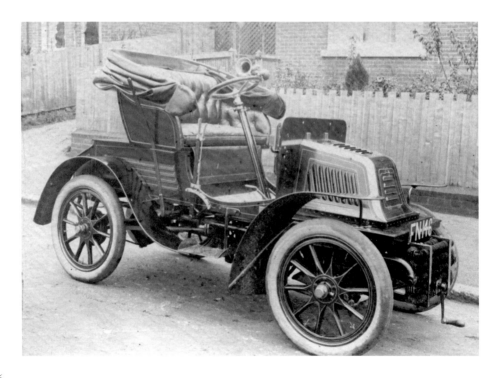

The 1,000 Miles Trial organised by the Automobile Club of Great Britain and Ireland was again being run in 1903. *Car Illustrated Magazine* on 30 September reported:- "The run to Folkestone and back on Tuesday started under very depressing conditions, rain and mist both being present at the start and to a considerable extent throughout the day. So far as concerns the rain, however, it was not unwelcome, the competitors already having suffered considerably from the dust. The run was perhaps the most uneventful of the week, as there were no police molestations and no official hill-climb to interrupt the even tenour of the competitors' progress. Only two vehicles retired during the day despite the length of the journey, 137 ½ miles. It may be added that, as drawn up in the grounds of the Hotel Metropole at Folkestone, the cars presented perhaps the most imposing tableau of the entire week."

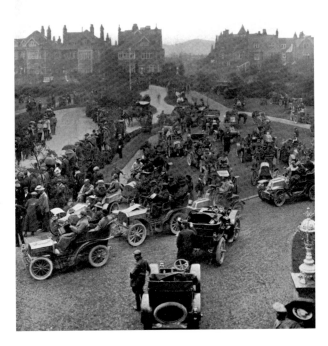

A KENTISH HILL-CLIMBING COMPETITION.

OVER twenty cars were present at the recent hill-climbing trials conducted by the Kentish Automobile Club. Eleven of these competed in the first climb, which was up Vigo Hill, on the road from Wrotham to Gravesend. The hill is half a mile in length, and the steepest gradient is 1 in 9. The following official results are furnished us by Mr. E. F. C. Dowding, M.R.C.S.:—

		Passengers.	Time. M. S.	Miles per hour.
Hall, H. O.	24 h.p. Darracq	4	1 11	25·3
Lucas, R.	12 h.p. Lucas	2	1 40	18·0
Edwards, W. T.	14 h.p. Renault	4	1 53	15·9
Packham, E.	5 h.p. Peugeot (Baby)	2	2 18	13·6
Cornell, A.	5 h.p. Peugeot (Baby)	2	2 38	11·4
Hearne, A. B.	9½ h.p. Clément	4	2 56	10·2
Morgan, C. J.	7 h.p. New Orleans	4	3 10	9·4
Spencer, S. L.	10 h.p. Gladiator	4	3 13	9·3
Morgan, C. J.	12 h.p. Brooke	4	3 16	9·2
Bull, F. C.	8 h.p. Peugeot	4	3 47	7·9
*Hallows, F. S.	12 h.p. Belsize	4	4 0	7·5

* Two stops through missing gear.

After an interval for tea the members repaired to Trotterscliffe Hill, which is 1,700 ft. in length, and for one-third of that distance has the appalling gradient of 1 in 5·2. Only three cars ventured to tackle this hill. Results :—

		Passengers.	Time. M. S.	Miles per hour.
Lucas, R.	12 h.p. Lucas	2	1 42	11·4
Hall, H. O.	24 h.p. Darracq	4	1 50	10·6
Hallows, F. S.	12 h.p. Belsize	5	3 10	7·2

"20TH CENTURY" HEADLIGHTS.

Stand No. 8

SOUTH BRITISH
TRADING CO.,
LTD.,

*Direct
Representatives,*

6
VICTORIA
AVENUE,

Bishopsgate
Street Without,

LONDON,
E.C.

"LA BELLE" MOTOR HEADLIGHT, No. 24.

Total height, 15 inches. Extreme depth, 11¾ inches.
Diameter, front Reflector, 8 inches. Weight, 14 lbs.
Finished as No. 22. Price **£7 2 0** each.

"GRAND" MODEL MOTOR, No. 21.

Height (not including Bail) 13 inches.
Diameter, front Reflector, 9 inches.
Weight, 6 lbs.
Made of Brass, highly polished.
Price **71 -** each.
Also made in Tin Plate and Japanned finish.

"LA BELLE" MOTOR HEADLIGHT, No. 22.

Total height, 13 inches. Extreme depth, 10 inches.
Diameter, front Reflector, 6 inches. Weight, 10 lbs.
Burns 8 to 10 hours. Made of heavy brass and steel.
Finely finished in nickel-plated, gun metal, or burnished brass. Price **£5 7 6** each.

VOITURETTE OR DRIVING, No. 10.

Height with Bail, 10½ inches. Diameter,
front Reflector, 6 inches. Weight,
36 ounces.
Price **25 6** each.

MOTOR TAIL LAMP, No. 9.

Price **17/-** each.
These Lamps throw a strong rear
light. Furnished with eight Red or
Green Glasses.

18

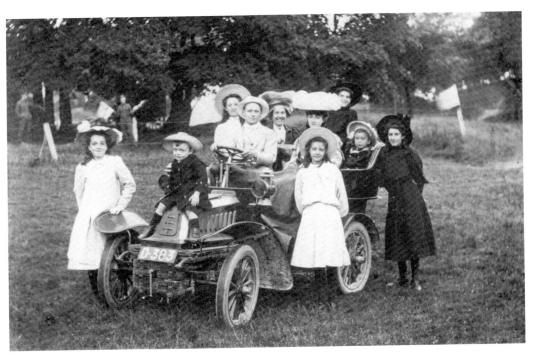

Above and below: This two cylinder DE DION BOUTON of 1904 (or late 1903) and registered D-383 is seen in these pictures in later life, during World War One. It must have belonged to a photographer as his negative number appears on some pictures. Although a very old car (the advances in motor car design before the war were far more rapid than at any period since) there were plenty of soldiers and others who had never sat in a car and were pleased to have these postcards to send home.

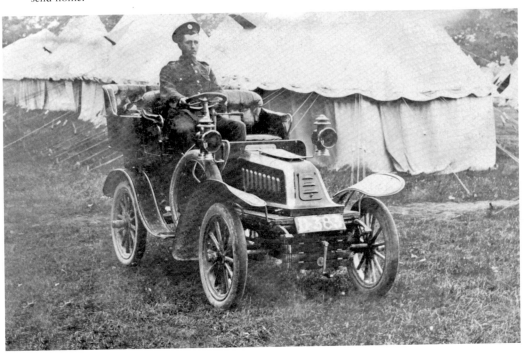

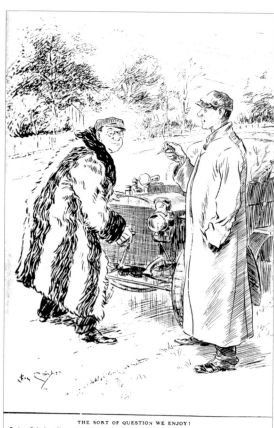

THE SORT OF QUESTION WE ENJOY!

Curious Onlooker : Now, mister, how far do yer reckon your car'll go wi' just that one turn o' that there 'andle ?

Below: Another DE DION BOUTON, this one from 1903 with a 1 January 1904 Kent registration. It is a single cylinder 6h.p. model registered to H.B. Webster of Chislehurst. It is not easy to be sure, but the two-seater body looks to have been up-dated and the windscreen and hood fitted. Perhaps in 1909/10?

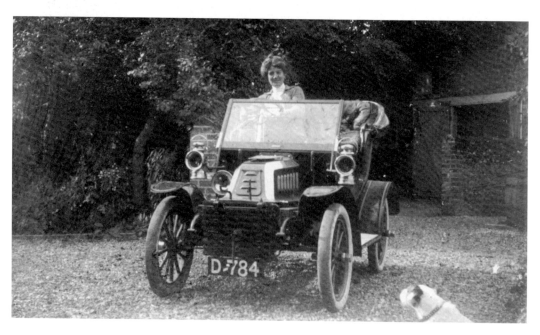

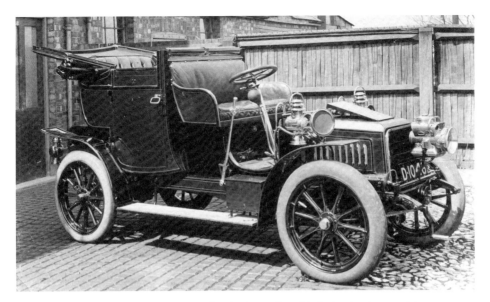

Kent-registered in 1904 this car is unusual in having a closeable body: the door uprights are folded across the front seatback and the glass side windows lowered into the doors on what we remember as railway carriage straps. The car is a 1904 DARRACQ 2 cylinder eight horsepower belonging to John Ranking of Tunbridge Wells. The steering column gear-change lever can just be seen above the horn bulb; the horn itself is awkwardly mounted on the front wing. Most cars of the time had two (sometimes three) side levers, but here only the hand-brake lever is necessary.

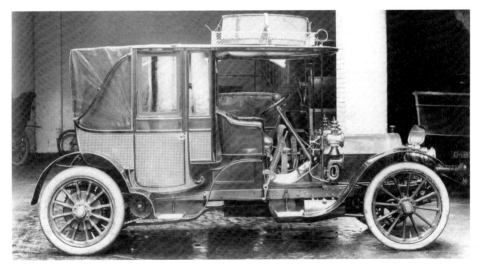

What a magnificent motor car, an open drive landaulette, possibly bodied by Kellner of Paris on a MERCEDES 28/32 chassis in 1904.

It is believed it was owned by the Sultan of Johore and then registered D-3253 to Mrs C.B. Ward in May 1907. Later it was bought by Edward Mayer who had an open body fitted.

The wings of the car are of japanned leather including the one in the centre of the car which is a feature to give the style of a horse-drawn vehicle where the coachman's box would have been above the front wheels and the front axle with centre pivot would have turned underneath the box on a tight turn.

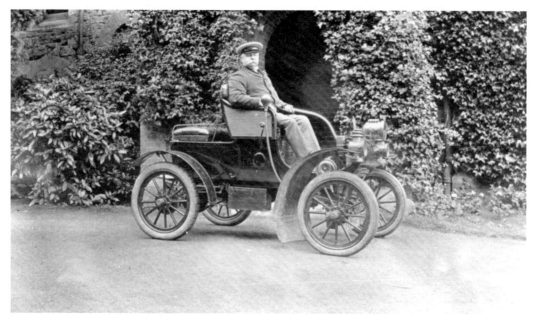

Above and below: The 7h.p. "curved dash" OLDSMOBILE was made in Detroit and was America's best-selling car in 1903 and 1904. It had an excellent but simply designed horizontal single cylinder engine in a rectangular chassis with long springs on each side reaching from axle to axle. Steering was by a long central tiller. The seat has been replaced with a more comfortable and substantial English one and the "Stepney" spare wheel is extra as are the two rear-facing seats above the engine.

This was the first car bought by de Barri Crawshaw of Rosefield, Kippington Road, Sevenoaks. Mr Crawshay bought his Oldsmobile from Mrs Rogers of Riverhill. He must have put this D 3791 registration on it. He transferred the registration to his next car, a 1909 Straker Squire (described later).

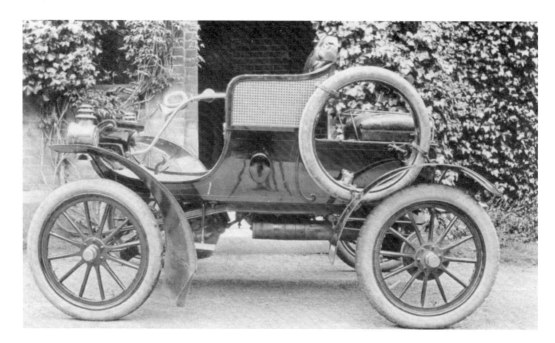

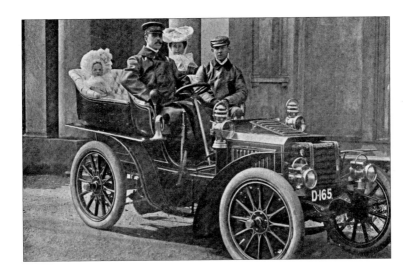

The Mayor of Tunbridge Wells in 1904 was E. Elvy Robb J.P. In the summer of 1903 he decided to become a motor car owner with £500-£600 to spend. For the hilly country around Tunbridge Wells he needed a four-seater of sufficient power. Mr Robb tried a 16h.p. two-cylinder MAXIM made in London but although taken by the car he expressed doubts about the make as the company had been in existence less than a year. Maxims offered "you may select any car from our stock and submit it to any test you please upon payment of a reasonable deposit to cover wear of tyres etc. If at the end of a fortnight you are not satisfied with the car you can return it to us." Mr Robb drove about 1,000 miles including Westerham Hill, River Hill and Folkestone Hill and then purchased the car "without hesitation". A year later he was still very pleased with his purchase.

Maxim cars were made in London from 1903 to 1905. The designer was Hiram Maxim, the inventor of the Maxim gun. This car had a two-cylinder T-head Fafnir engine, a 3-speed gearbox and final drive by side chains.

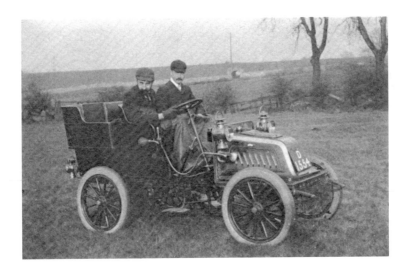

This car was first made as a CLEMENT-BAYARD in Levallois-Perret, Paris, and then as a CLEMENT in London. The picture shows the twin cylinder 9h.p. model bought by Jonathan Oliver of Margate in March 1904.

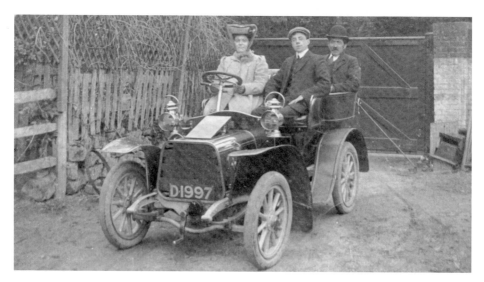

This is an 8h.p. DARRACQ with rear entrance tonneau body. It was Kent-registered in June 1905 to a surveyor, Frank Harris of Bidborough. These cars go very well and the film car "Genevieve" was of the same model but a two-seater. Note the steering column gear change lever as on all Darracq cars of this period.

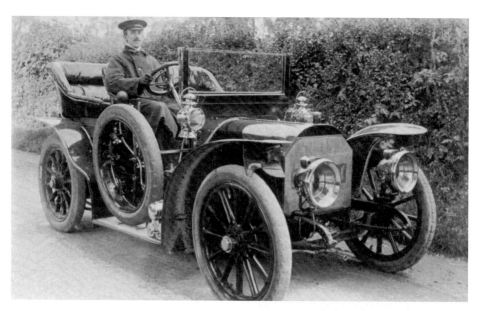

What a wonderful new car for chauffeur-mechanic William Edwards to be driving. The car is a 6oh.p. MERCEDES of 1904 with four-seat body on a very short chassis preventing side access. One could have expected to see a central rear door, but not in this case. A tipping or swivelling front passenger seat may have been incorporated to allow entry. A brass acetylene lighting generator is on the running board ahead of the Stepney spare wheel (Stepney wheels were only available from 1904). The side lights are oil powered.

The car belonged to the Wheeler Bennett family of Keston Park and must have been photographed for its owner when newly arrived.

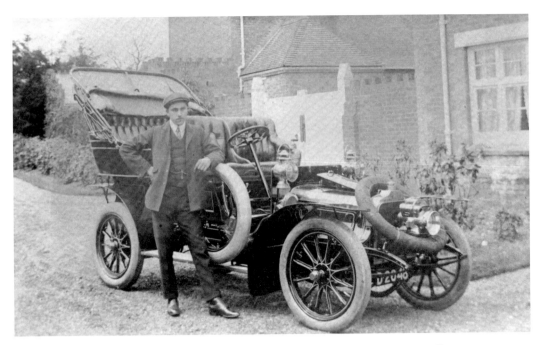

Above and below: A TALBOT of 1905 made in North Kensington by Clement Talbot, a company backed by the Earl of Shrewsbury and Talbot but with some French Clement input. 1904/5 was when rear entrance to the back seats was abandoned in favour of side entrance. The bugbear of unpaved roads littered with broken horseshoes and horseshoe nails meant many punctures so this owner carries two spare tyres but one is mounted on a Stepney wheel rim. The Stepney rim was actually made in South Wales and in those days before road wheels were detachable other than in a garage, the spare tyre, already inflated on its rim could be fitted onto the outside of the punctured tyre.

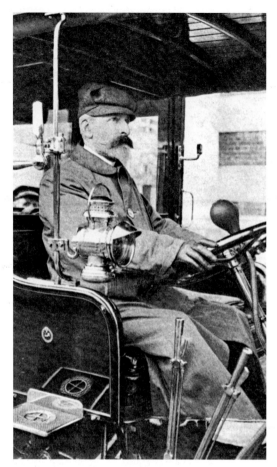

Left and below: Broomhill, near Tunbridge Wells is still well known as the Edwardian home of Sir David Salomons, Bart. He inherited Broomhill on the death of his uncle in 1869 and much enlarged and improved it thereafter. In 1895 whilst he was the Mayor of Tunbridge Wells he organised, at his own expense and in connection with the Tunbridge Wells Agricultural Show, the first exhibition of motor cars ever held. This was a year before the Emancipation Act. Sir David formed the Self-Propelled Traffic Association in November 1895, the outcome of which was the abolishment of the four-miles-an-hour limit and of the walking signalman with his red flag in November 1896. He was also very supportive of the Automobile Club of Great Britain and Ireland which later became the R.A.C.

We have a record that by 1906 Sir David Salomons had already owned thirty-nine different cars. The one shown here is a BRASIER, previously marketed by Georges Richard, whose racing Brasiers had won in both 1904 and 1905 the Gordon Bennett Trophy Races for France bringing great prestige to the name. This limousine has a four-cylinder engine of 50h.p. and chain drive, and is seen outside the garage, stables and workshop buildings of Broomhill.

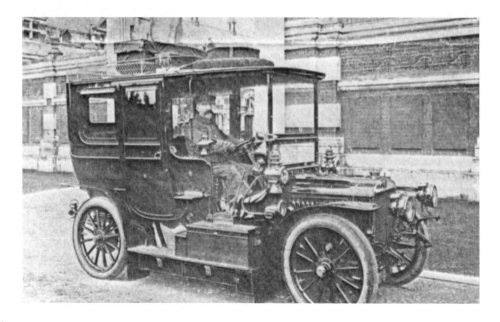

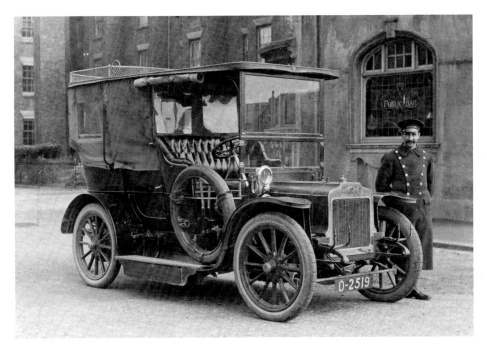

Originally by Georges Richard, by 1902 the cars were Richard-Brasiers and from 1904/5 when they twice won the Gordon Bennett Race they were Brasiers. This is a 1906 BRASIER tourer but fitted with a detachable hard-top roof and celluloid or canvas screens. We are told on the postcard that the chauffeur was Mr R. Clarke and the car was owned by Lady E. Vaughan. The photo was taken in Dover.

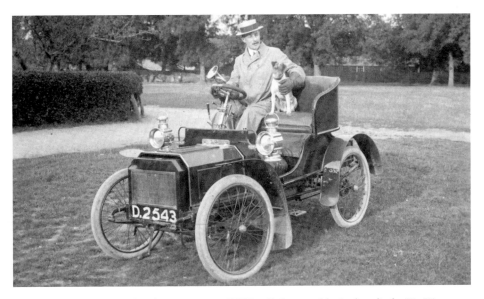

Introduced in 1903 was the 5h.p. HUMBERETTE, a little car with single cylinder De Dion Bouton engine of 613c.c. and a separate steering column lever for each of its two gears. The card was posted from Sheldwich Lees in December 1907 when the car, registered in May 1906, would still have belonged to Reginald Wilson of Faversham.

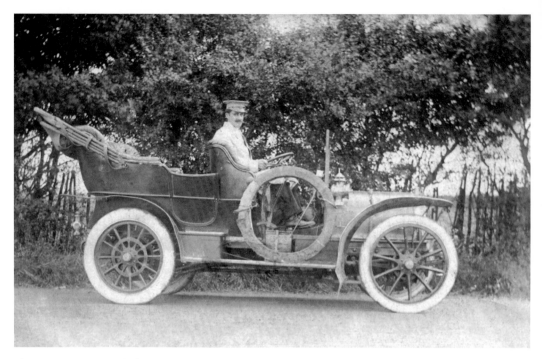

The PRUNEL was made from 1900 until 1907 in Puteaux, Paris. A wide variety of cars were made. The only thing we know about this one is on the back of the card. It reads: "G. Gale, 25 Gladstone Road, Broadstairs. Prunel £110."

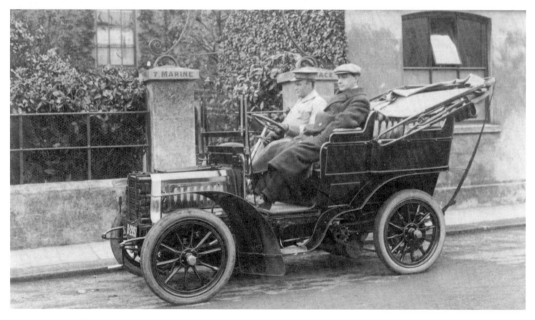

Chain drive still with a rear entrance door (under the hood) and a gilled tube radiator in 1906. GLADIATOR was a French company but partly British-owned. This is a 12/14 with four cylinders and it is photographed outside 7 Marine Terrace, Herne Bay.

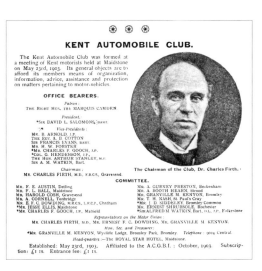

KENT AUTOMOBILE CLUB.

The Kent Automobile Club was formed at a meeting of Kent motorists held at Maidstone on May 23rd, 1903. Its general objects are to afford its members means of organization, information, advice, assistance and protection on matters pertaining to motor-vehicles.

OFFICE BEARERS.

Patron :
THE RIGHT HON. THE MARQUIS CAMDEN.

President :
*SIR DAVID L. SALOMONS, BART.

Vice-Presidents :
MR. B. ARNOLD, J.P.
THE REV. A. B. COTTON
SIR FRANCIS EVANS, BART.
MR. H. W. FORSTER
*MR. CHARLES F. GOOCH, J.P.
*COL. G. HENDERSON, J.P.
THE HON. ARTHUR STANLEY, M.P.
SIR A. M. WATKIN, BART.

Chairman ;
MR. CHARLES FIRTH, M.D., F.R.C.S., Gravesend.

COMMITTEE.

MR. F. E. AUSTIN, Detling
MR. F. L. BALL, Maidstone
MR. HAROLD COSH, Gravesend
MR. A. CORNELL, Tonbridge
MR. E. F. C. DOWDING, M.R.C.S., L.R.C.P., Chatham
*MR. JESSE ELLIS, Maidstone
*MR. CHARLES F. GOOCH, J.P., Matfield

MR. A. GURNEY PRESTON, Beckenham
MR. A. BOOTH HEARN, Strood
MR. GRANVILLE M. KENYON, Bromley
MR. T. H. NASH, St. Paul's Cray
*MR. J. D. SIDDELEY, Bromley Common
MR. ERNEST SHRUBSOLE, Rochester
*SIR ALFRED M WATKIN, Bart., D.L., J.P. Folkestone

Representatives on the Motor Union
MR. CHARLES FIRTH, M.D., MR. ERNEST F. C. DOWDING, MR. GRANVILLE M KENYON.

Hon. Sec. and Treasurer:
*MR. GRANVILLE M. KENYON, Wycliffe Lodge, Bromley Park, Bromley. *Telephone :* 9024 Central.
Head-quarters.—The ROYAL STAR HOTEL, Maidstone.

Established: May 23rd, 1903. Affiliated to the A.C.G.B.I. : October, 1903. Subscription: £1 1s. Entrance fee: £1 1s.

MEMBERS (in addition to those above).

Adams, H.	Ievers, E., M.D.
Arnold, B., J.P.	Igglesden. C.
Arnott, E.	Jackson, Rev. W.
Austin, J. E.	Johnson, J. Y. L.
Ayles, T. F.	Keetley, C. B., F.R.C.S.
Baily, F. W.	Killick, A.
Batchelor, A.	Laslett, M. H.
Bond, G. E.	*Latter, Col. E.
Bryan, H. J., M.R.C.S.,	*Lucas, R.
L.R.C.P.	McFarland, A. J., M.D.
Cobham, G. W.	Macfarlane, G. M.
Cornell, A.	Madeley, J. C.
Cosgrave, J. C.	Mann, F. H. D.
*Cosh, H. L.	Mapplebeck, W. H.
Cosh, R. L.	Marks, H. H., J.P.
*Critchley, J. S.	Maybury, H. P.
Dampier, H. L., J.P.	Morgan, C. J.
Day, W. H. W.	Morgan, R. C. E.
*Dieseldorff, W. H.	*Muirhead, R.
Drake, J. A.	Noakes, W. J.
Drew, A. H.	Norman, A. R.
Eagleton, L.	Nunn, A. E.
Ellice-Clark, E. B.	Packham, E.
*Englehardt, H. T.	Page, S. H.
Evers, C. J., M.D.	Paton, W. F.
Firth, C., M.D.	*Peall, W. J.
Firth, O.	Peters, W. K.
Fletcher. A. G.	Porter, H. A.
Fraser, H. J.	*Powell, L.
*Gardiner, H.	*Preston, E. M.
Gardner, C. B.	Preston, G.
Griffiths. F.	Pritchett, S., M.D.
*Ground, E., B.A., M.D.	Purvis, Major J. S.
Hall, H. O.	Randall, I.
Hilder, C. T.	Reed, A. H.
Holman, H. F.	Ryland, T. H.
Holroyd, B. D.	Selby, P., M.R.C.S., L.R.C.P.
Hordern, A.	Simpson, A.
Hordern, A. G.	Simpson, P. A.

Smith, T., M.D.
*Soames, A.
Spear, Rev. W.
*Spencer, T. L.
Stanford, Dr. W.
Stace, J.
Steinhoff, F.
Stevens, W. A.
Sutton, G.
Symmonds, W.
Tamplin, Dr. C. H.
*Topham, T. H. (Major R.E.)
Travers, F. T.
Valance, O. A.
Vernon, C. M., M.R.C.S., etc.
Waddington, R.
Walker, A. H.
Warde, Col. C., J.P., M.P.
Waters, F. W.
White, E. A.
White, H. G.
Wilding, R.
*Willis, W.
Winch, R.
Wyllie, W.

* Also Members of the A.C.G.B.I.

The Club Badge.

Right: A list of the members of the Kent Automobile Club recorded in the *Motoring Annual and Motorist's Yearbook 1906.*

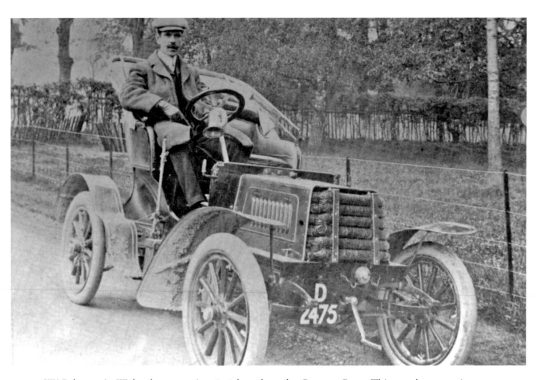

STAR began in Wolverhampton in 1898 based on the German Benz. This one has 1904/1905 appearance but was registered in 1906. Early Stars seem to have had a high seating position. The first owner was Fred Cooper of Maidstone.

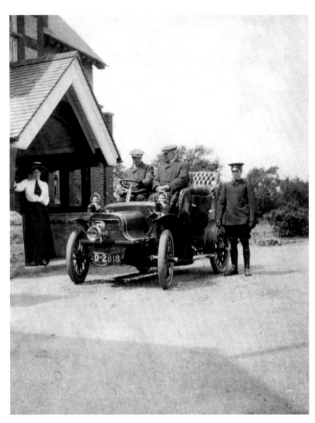

Left: The Cadillac from Detroit was not unknown in England in 1906. This is a ten horsepower model M CADILLAC "Light Touring car". The horizontal 5in x 5in single cylinder engine was beneath the front seats. The false bonnet was necessary because motor-car design was advancing so fast with most cars having now got front engines. This postcard from Borough Green in 1910 says "I can picture you this weather coming down with your shawl on, how do you like this!"

Below: Kent-registered in 1907 this DARRACQ was not photographed until at least 1911 when the AA badge changed its overall shape from circular to having wings above it to reflect the AA's amalgamation with the Motor Union (the badge is at the centre of the dashboard). Darracq features are the spark-plug distributor protruding through the front of the radiator and the steering column gear change, whose lever is below the wheel. 1907 is very late for a car not to have side-entrance for the rear seat passengers.

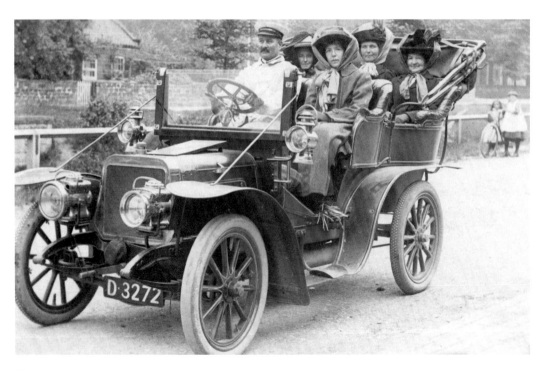

Right: Antwerp was the birthplace of MINERVA cars. This is the 24h.p. of 1907, just before the company started to use the Knight sleeve valve engine. The company lasted until 1939. The car belonged to Henry Summers of Ramsgate.

Below: Until 1908 Humber cars were made in two factories, at Coventry and Beeston, the latter being more expensive. This is a 1907/8 HUMBER of 15h.p. made in Coventry. The windscreens on cars at this time were seldom supplied as standard and could not have supported the front of the hood. The hood is strapped to the front wings and in this case the top half of the screen is folded.

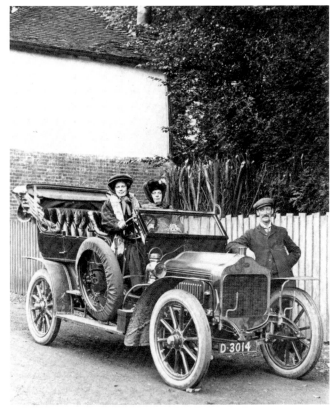

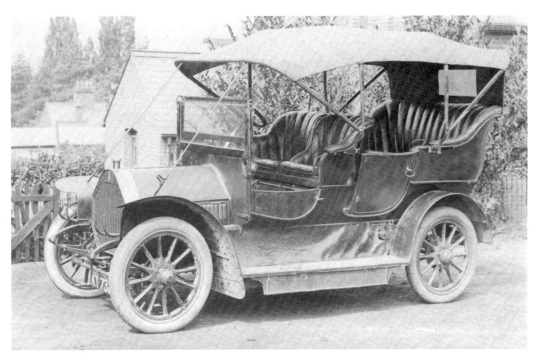

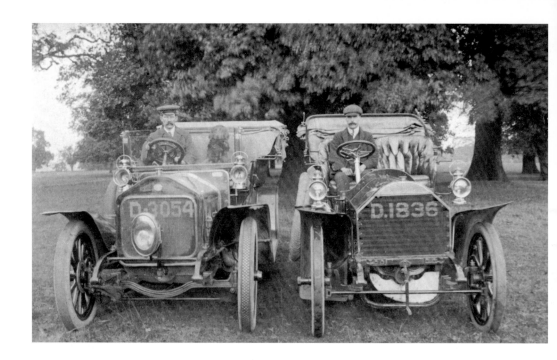

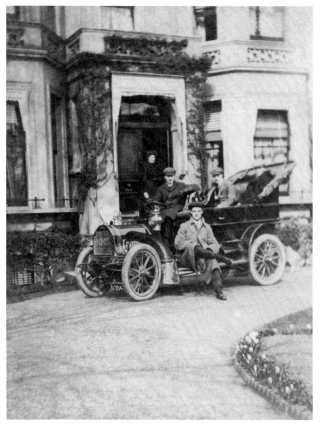

Above: Two Kent-registered cars pose. On the left is a 1907 WOLSELEY SIDDELEY, which is the 7.7 litre 4 cylinder 40 with shaft drive.

On the right is a WHITLOCK-ASTER car of two years earlier. It had an ASTER chassis, imported from France, with a body by Whitlock, in London, who were established coachbuilders. Both cars belonged to Louis Kekewich of Lamorbey Park, Sidcup.

Left: This Kent-registered 1907 GERMAIN is a Belgian make that lasted until 1914.

A real rarity. CHATER-LEA made a conventional light car from 1913 to 1922 but had had an earlier try in 1907 using a two-cylinder, air-cooled, twin engine mounted on the offside of the chassis. How this ephemeral creation found its way from London EC, where it was made, to be pictured by a photographer in Strood, still without a registration, is a mystery.

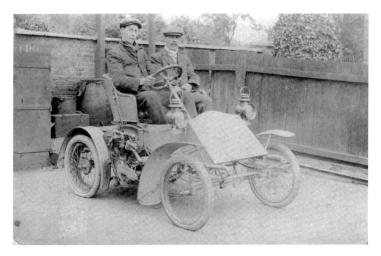

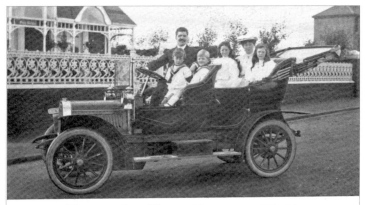

With every Good Wish for Xmas and the New Year from Mr. & Mrs. Bertie Gill.

BORSTAL, ROCHESTER.

1907

Middle and below: This Christmas postcard of 1907 shows a happy family with their Scottish ARGYLL car.
The lower picture shows another Scottish ARGYLL but this time a limousine, of 16/20 h.p., whose first owner in 1908 was Lord Ronald Sutherland Gower, of Hammerfield, Penshurst.

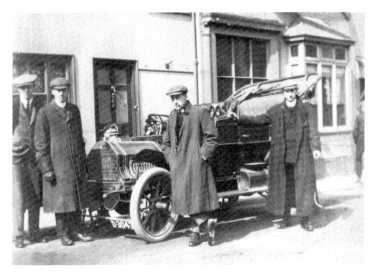

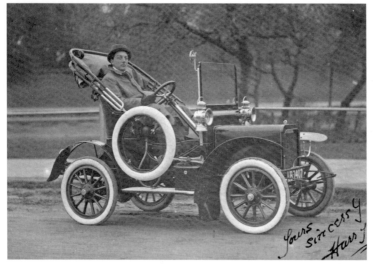

A previous owner of this postcard has kindly left some information on the back. The driver is Harry Sheppard, proprietor of St Peter's Garage, 14 Church Street, Broadstairs. The authors can supply the information that the car is a 1908 ROVER with single-cylinder engine of 6h.p. The presence of a driving mirror was very unusual at the time.

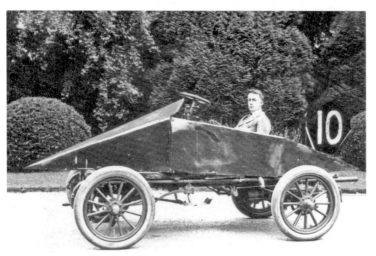

R.V.E. de V. Crawshay of Sevenoaks created this ungainly racer from an old single-cylinder 8h.p. DE DION BOUTON. He entered it in the Whitsun Private Competitors' Handicap at Brooklands Circuit but without success.

The gilled tube radiator must still be low-set around the starting handle and the driver now sits too low to see over the steering wheel.

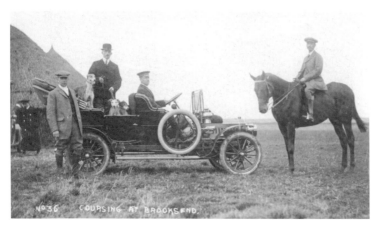

The bowler-hatted hunter has three whippets in the back of his 1908 French DE DION BOUTON and the caption indicates that hare-coursing is the sport at Brooks End, near Margate.

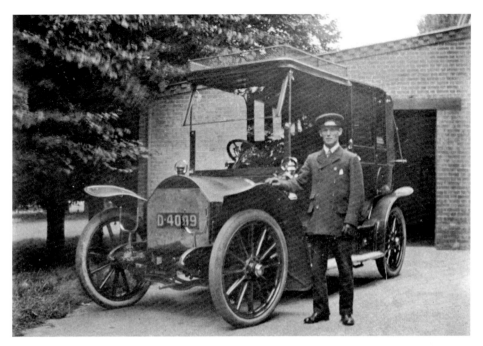

The purchase of a motor-car was a very big event one hundred years ago, a momentous change of life for any long-established family. Many of the pictures at this period show brand new cars and the chauffeur in his new uniform. The owner would have had the local photographer attend to take the photo, though the owner would not necessarily have been present. Here we have a MERCEDES 30h.p. landaulette of 1908, owned by the Hon. Henry Miller-Lade, of Nash Court, near Faversham.

The Purvis family in their HUMBER car of *c.*1908 photographed in August 1920 in front of Stickles photographic shop in High Street, Cranbrook. From 1904 to 1910 Humber cars had steering wheels with but a single spoke, a feature invented some fifty years later by Citroen for its DS19. The people in the photographer are "Rene, my mother, me, Dad and uncle" Arthur Stickles beside the car.

Left and below: River Hill House at Sevenoaks was the home of Colonel and Mrs John Rogers. Here they are (below) in the avenue leading up to the house. The Colonel is in his 1905 28-36h.p. DAIMLER tourer with detachable top and Mrs Rogers in her newer 1908 22h.p. DAIMLER two-seater with "Silent Knight" sleeve valve engine. It was reported in 1909 that Mrs Rogers, a keen lady motorist, said "there is not really half so much fun in motoring as there used to be". It was also reported in 1909 that "on more than one occasion she toured for several days, together with a girl friend, but without any servant, and entirely without the aid of a chauffeur".

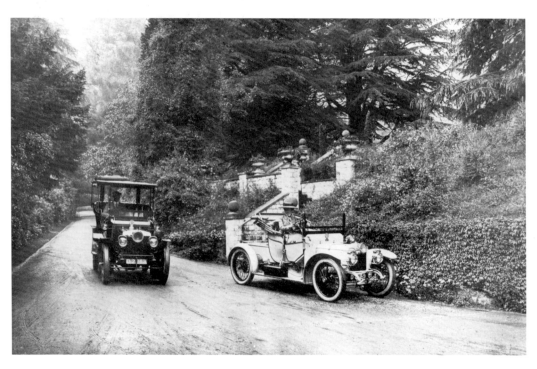

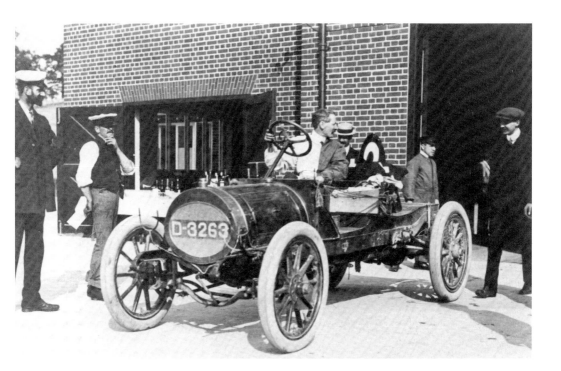

Above and right: The scene is Brooklands surely in its opening year 1907. The car is a Belgian GERMAIN of that year with the oval radiator that preceded a round one. Note how the steering wheel would have been more comfortable for a body with higher seating.

When Brooklands opened it was the World's first purpose-built motor racing circuit. There was thus no precedent to use. Head-style was yachting caps, car numbers were on big vertical roundels at the back, there were book-makers on the course and here is seen the wearing of coloured "silks" by the driver.

The driver of this Kent-registered GERMAIN is reversing it into the Clubhouse to put it on the weighbridge.

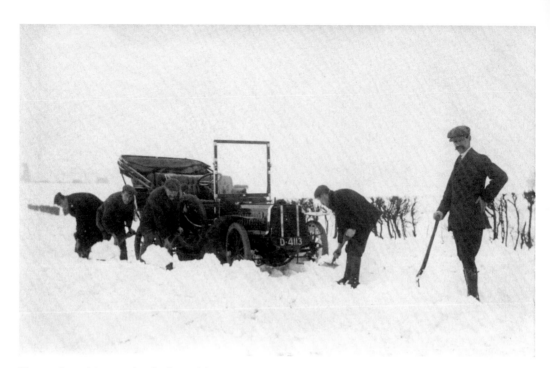

Kent-registered in 1908 but looking older is a GLADIATOR 12/16 in the snow at Herne Bay. The card message says "This is our motor in the snow ... Fanny".

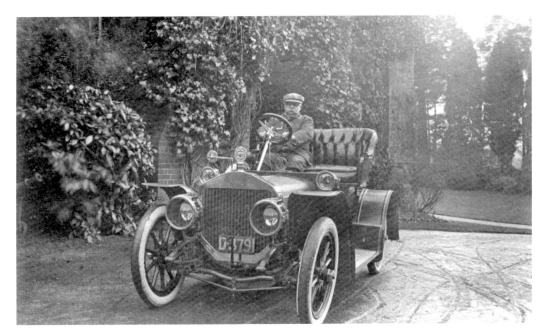

This page: The STRAKER-SQUIRE was made in Bristol before World War One and at Edmonton, London in the twenties. This is the model 12/14 4-cylinder two-seater registered in April 1909 to de Barri Crawshay of Rosefield, Sevenoaks. On earlier pages we see Mr Crawshay with an 1899 Benz and then again with a 1904 Oldsmobile. For some reason he transferred the Oldsmobile registration to this Straker-Squire. He seems to have kept the car at least until 1920 but cars of this date do need two hands to control them so the pussycat on his shoulder would have been worse than today's mobile phones!

Wings were being advertised in the motoring press at the time. All cars at the period up to 1914 had flat-topped wings so domed wings would have been quite avant-garde and here the car is seen before and after having them fitted.

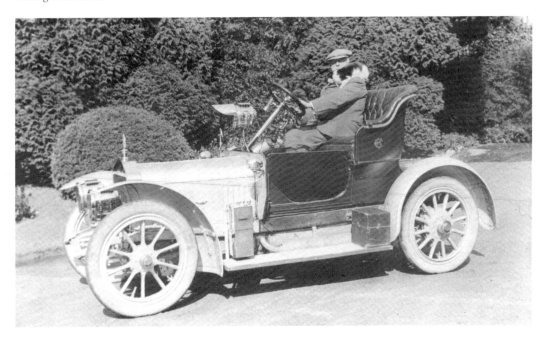

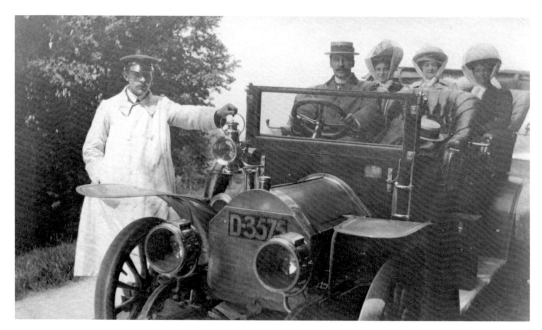

Above and below: New at Christmas-time 1907 was this FIAT (top). One would imagine the photographer's boater is on the front seat, there are three ladies in the back so once the chauffeur has swung the motor into life where is he going to sit? At this time the driver always had to get in before the passenger as the gear lever and hand-brake prevented access from the offside.

Below, Kent-registered in 1909 is a FIAT still with final drive by chains. The body is British and could be a couple of years later than the chassis. It is an all-weather body so can be partially or fully opened. Registration records say it is a 22h.p. A.W. Bangham was a taxi proprietor in Margate and owned both these cars.

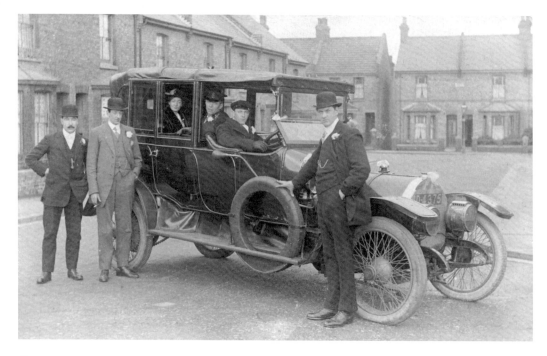

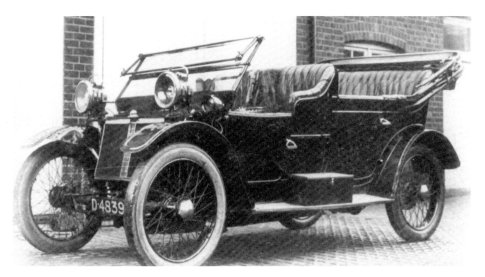

The LANCHESTER was a quite individual make with many idiosyncratic features. This one was owned by J.C. Beadle of Dartford dating from 1909 and has suspension by cantilever springs all round and tiller (instead of wheel) steering which was an option until 1910. The 20h.p. four-cylinder engine is placed between the front seats with all the controls on a panel above it.

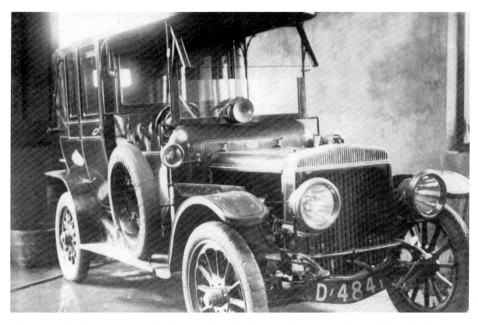

This four-cylinder DAIMLER landaulette has the sleeve valve engine designed by Charles Yale Knight whose invention was said to make an engine much more silent than one with the poppet valves that had been in universal use until 1908 and would be again from the 1930s when the sleeve valve engine was abandoned.

The sleeve valve principle involved the use of one or two steel sleeves between the piston and the bore. These sleeves were moved up and down a small amount to expose the inlet and exhaust ports at the right times. Lubrication of the sleeves was always a problem and most sleeve-valve cars left a haze of oil smoke in their wake.

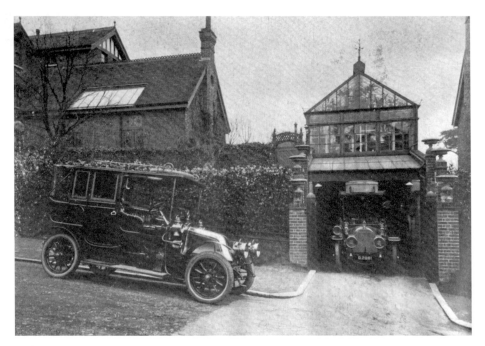

Above and below: 'The Braes' Tunbridge Wells was in 1909 the home of Mr Elliott Alves. This large house had a small garden with two greenhouses. Below there was hidden a three car garage with boiler (for garage and greenhouses), chauffeur's changing room, pit, electric light and telephone to the house. The ceiling and walls were lined with white glazed tiles.

In 1909 Mr Alves had five cars – a 65h.p. Isotta Fraschini, a covered touring car de luxe which had seen much service on continental tours, a 20/30h.p. Renault landaulette "for station and town work", a six-cylinder seven-seat Lanchester and two Darracqs, one a 15h.p. landaulette, the other a 10h.p. runabout.

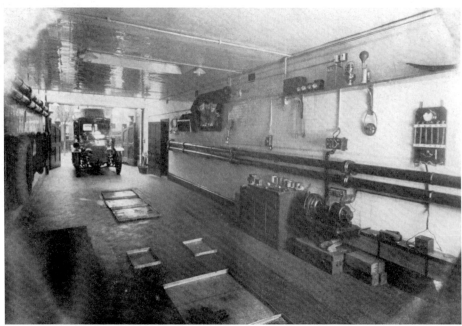

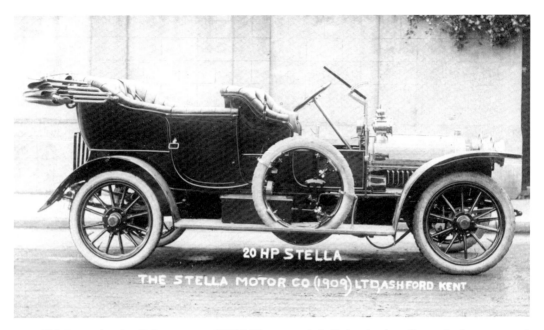

This is a real rarity. Only some 200 STELLAS were made in Switzerland, at Geneva in the years 1906 to 1913 but here we have the company trying to get into the British market in 1909 with premises in Ashford. The STELLA had a round radiator but was otherwise conventional.

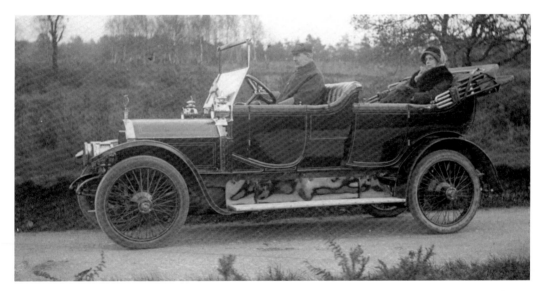

This is a 15h.p. NAPIER of about 1910 showing how the shape of the car was beginning to evolve from the horse age. From the dashboard forward was "the horse" now replaced by the engine. The dashboard originally had the reins over it and was to stop mud or "dashes" from the horses' hooves (or worse!) – a word we still use. The centre portion of the vehicle was once the coachman's box but now can be much lower. The rear portion was always for the owner. Few owners before the first war could drive. One can see that the car now has a waistline which in the next year or two would become the dominant line of the car.

This postcard was sent from 15 Sandford Road, Bromley with Christmas Greetings in 1913.

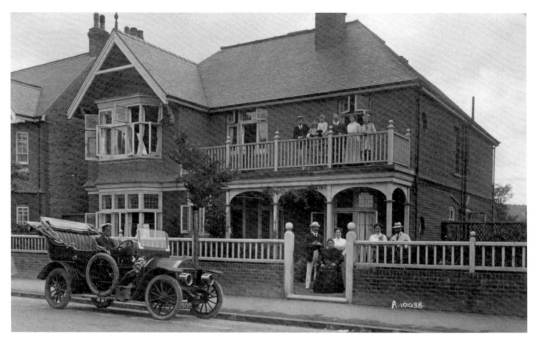

Presumably a family celebration party with the car and chauffeur parked to complete the picture. The card is sent from Margate with the message "this is a picture of our house and though I am sure you don't deserve it I am sending it but is the last till you write."

The car is a 1910 DARRACQ the smallest model of which that year was of 15h.p.

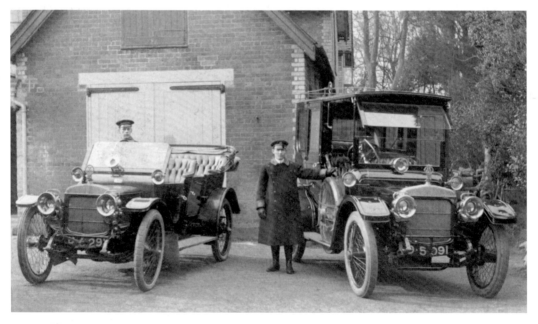

Two 1910 DAIMLER cars owned by Donald Kind of Southborough. The Knight double sleeve-valve engine had been adopted so the cars were smooth and silent but not lively. These are likely to be 15 and 30h.p. cars with Daimler's own bodies.

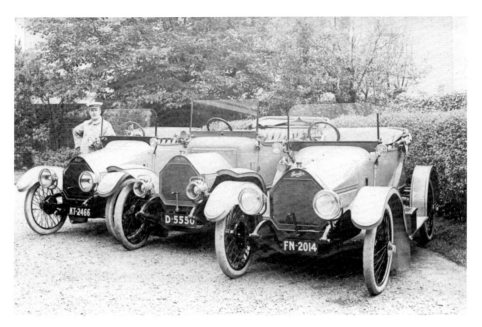

Three HUMBERS 1910 – 1914. The earliest, a 1910 12h.p. Humber is between two 1914 11h.p. Humbers Why these three Kentish cars are lined up we do not know.

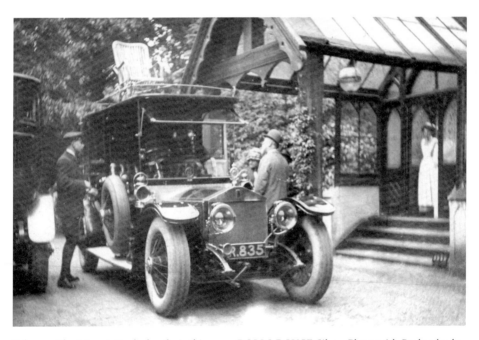

Taken at The Mount, Bexleyheath, is this 1910 ROLLS-ROYCE Silver Ghost with Barker body owned by C.H. Grey. The "R" registration is Derbyshire where Rolls-Royces were then made and many were registered. An unusual feature that was to become the norm twenty years later was the fitting of "balloon" tyres which must have made the steering of this 2 ½ ton car, before the days of power steering, very heavy. The Silver Ghost had a six cylinder engine of 7 ½ litres, renowned for its smoothness and silence. Was anyone going to travel on the roof!

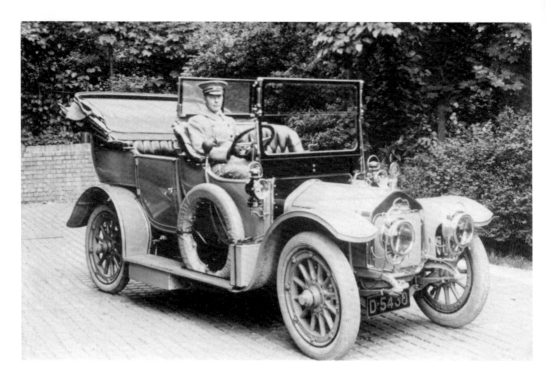

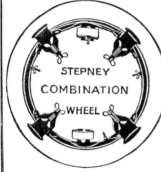
Above and left: Even smarter than most chauffeurs is this one in what must be grey uniform and perhaps in a car to match? The car is a Kent-registered WOLSELEY of 1910 with oil side-lights, acetylene headlights and a spare two-gallon petrol can on the side. As with nearly all cars of this period there is no driver's door and no necessity for it as the hand-brake and gear-lever prevent access. The spare tyre is fitted to a rim making wheel-changing an easy matter in the days when the roads were liberally littered with broken horse-shoes, nails and broken flints.

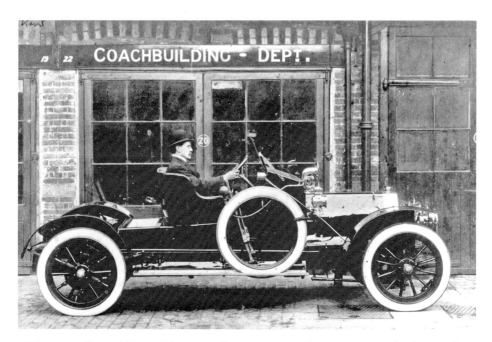

Mr Vernon Balls would be well known in the 1920s as British Concessionaire for the French Amilcar and racer of Amilcar Sixes at Brooklands. He lost the Amilcar licence in 1926 and from 1927 to 1930 he sold the French Derby in England as the VERNON-DERBY.

Mr Balls is here outside an unidentified coachbuilders at the wheel of another French car, a 1911 PORTHOS known as "Scarlet Satan" and supplied to Mr J.C. Style, brewer of Maidstone. It is likely that the white-wall tyres are the work of someone on the photo negative.

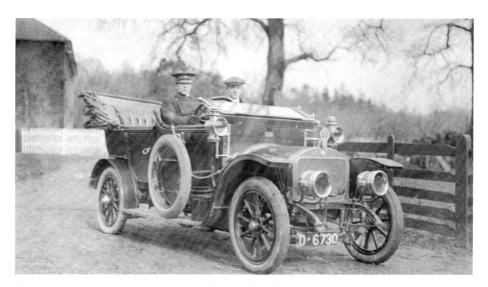

The famous designer Louis Coatalen had left HILLMAN of Coventry before 1911 when this tourer appeared with Kent registration. By 1911 most cars were losing the big square dashboard panel and beginning to get a body line having some relationship with the bonnet – but not this one.

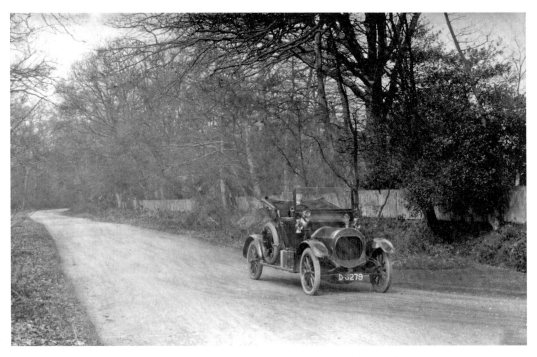

ENFIELD of Redditch was in trouble in 1907 and the company was sold to Alldays & Onions (see p. 50). Enfield became the name for upmarket Alldays cars. The picture shows a 1911 ENFIELD two seater with Kent registration.

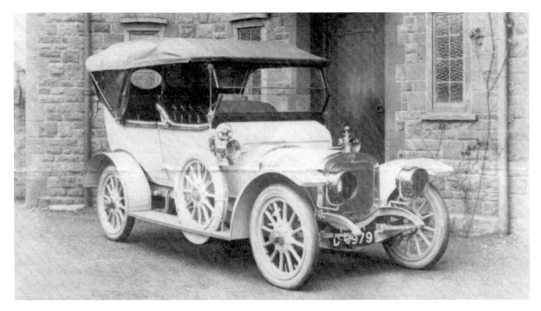

1911 was the first year for the 12/16 model SUNBEAM which was to be one of the best of the pre-World War One cars. The owner was Percy Graham Mackinnon of High Quarry, Crockham Hill, who later became Chairman of Lloyd's and received a knighthood.

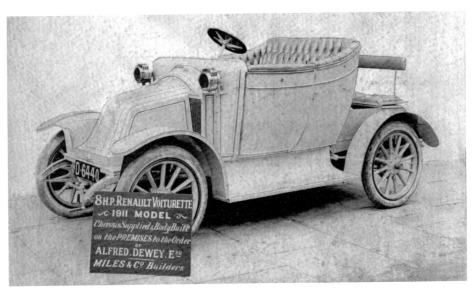

The RENAULT model AX was the company's smallest from 1907 to 1912 and yet the most successful. These cars have only two cylinders and 1205c.c. and until 1912 only two forward speeds and yet they go extraordinarily well. Why then should Mr Alfred Dewey of Sidcup have asked coachbuilder Miles & Co. to produce this odd conveyance? The AX RENAULT was sold with a two-seater body but here is a high-sided creation without windscreen and with dickey seats not allowing the occupants to see the road ahead. Note also the owner's crest on the door and the shape of the running board that the authors have not seen before! Only the flush top line of the door indicates the 1911 date when the old carriage style of lines both vertical and horizontal was changing to a more horizontal emphasis. This was not easy with the Renault rear-mounted radiator which the company did not fully abandon until 1930.

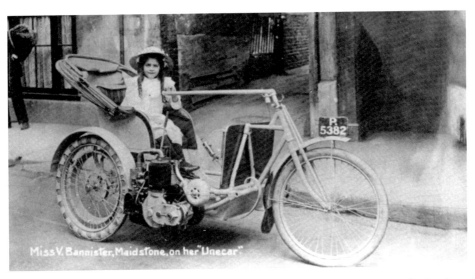

A charming photograph of a 1911 UNECAR in Maidstone. Miss V. Bannister was the daughter of W.W. Bannister of Maidstone who designed it. The engine is a single-cylinder, air-cooled unit on the outside of the tricycle, which was a monocar (or single-seater). One cannot help thinking of it as an invalid carriage.

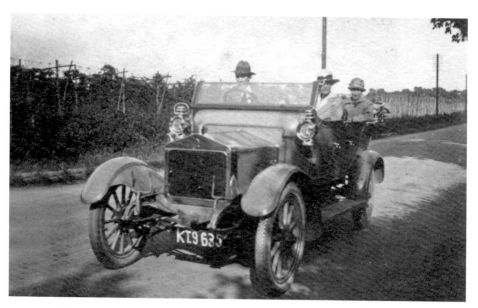

This 15/20 four-cylinder ALLDAYS & ONIONS four-seater was painted grey and presumably registered with a c.1911 number. In May 1917 the car was re-registered as KT9635. The second owner was William Rootes, garage proprietor, of 22 High Street, Maidstone.

William Rootes was born in Hawkhurst in 1894 and educated at Cranbrook public school. In 1915 he volunteered as a pupil engineer in the RNVR, became a Lieutenant in 1917, transferred to the Royal Naval Air Service – and bought this car.

The Maidstone motor business thrived. By 1923 William and his brother Reginald were Austin Distributors for London and in 1928 he was Deputy Chairman (with Reginald as Managing Director) of Humber. From these beginnings sprang the famous Rootes Organisation.

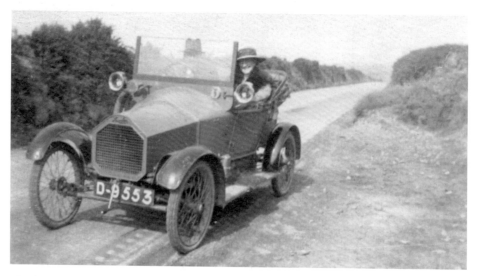

This little cyclecar is a HUMBERETTE of 1913, made by Humber Ltd, in Coventry. The engine was of 998c.c. and an air-cooled V-twin. It cost £120 or £135 if a water-cooled engine was specified. Some 2,000 of this model were made (1912-1914) and at less than 700lb they went quite well. The first owner of this example was William Randall of Chatham.

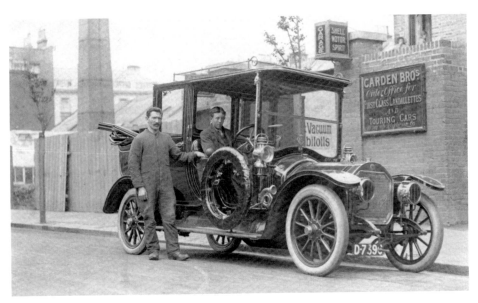

The notice advertised "Carden Bros. Order Office for First Class Landaulettes and Touring Cars. Ring up telephone 60." Based in Harold Road, Margate, it was also a garage selling Shell Motor Spirit, which was available at that time only in two-gallon cans. One would imagine that this French-made UNIC of 1912 is one of the "First Class Landaulettes" available for hire. Note that the petrol tank is situated behind the bonnet. A good proportion of London's taxis were Unics at the period but this is a slightly larger four-cylinder car, probably the 16/20h.p.

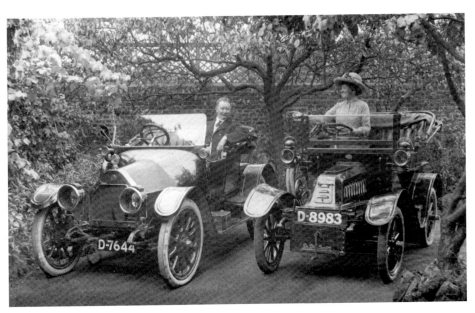

A 1912 BELSIZE (on the left) 10/12h.p. with its gearbox in unit with the 1,943c.c. engine and worm-drive rear axle. It belonged to Dr Edward Legge of Sheerness. Here it is seen with its original oil side-lights replaced with electric side-lights.

On the right is a 8h.p. DE DION BOUTON of 1903-1905 but carrying a much later registration number.

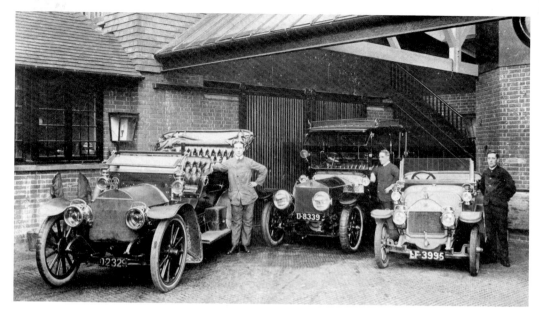

We assume this shows the garages of Mr E. Teichman of Chislehurst. The MERCEDES on the left is a few years earlier than the other two cars, the registration date being 1906. It did however survive to be rebodied as an ambulance during the Great War. The ROLLS-ROYCE is of 1912 and bodied by James Young as a landaulette. On the right is a little DARRACQ two seater also of 1912. These may be the three chauffeurs posing with their charges in the covered washing area.

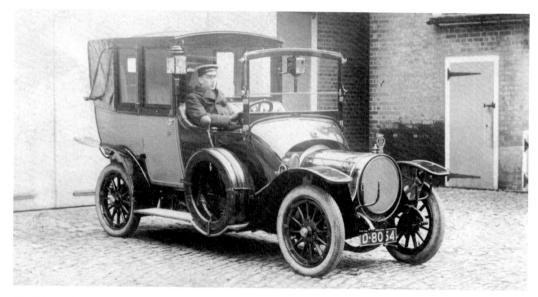

The big landaulette body on this DELAUNAY-BELLEVILLE of 1912 dwarfs the bonnet and has necessitated an ugly sloping scuttle. The car is a 17h.p. of four cylinders giving nearly 3 litres of engine. The largest Delaunay in 1912 had an engine of six-cylinders and nearly 12 litres. Notice the petrol-filler on the scuttle so the carburettor would have been gravity fed.

The shape of the windscreen top probably indicates that there is a canvas or leather cover to fit over the driver in wet weather.

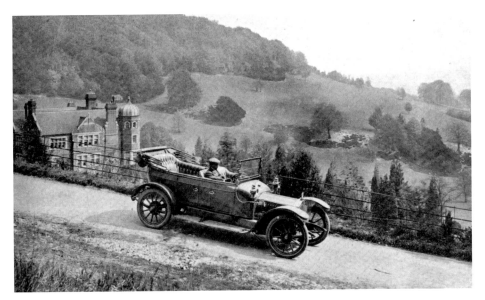

This 18h.p. DE DION BOUTON is on a road test in May 1912. The smaller De Dions were quite common in England but much bigger ones were made and this is in the middle of the range with a four cylinder engine of 80 x 140mm. The French horsepower rating was 14. There was even a V8 model introduced in 1911.

The reporter had borrowed it from the company's showroom off Piccadilly and his round trip to Kent was forty miles.

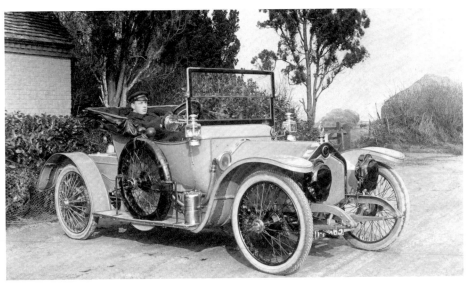

Here we have a new CROSSLEY 15h.p. two seater with fold-out dickey seat. The chauffeur poses proudly for the photographer. The acetylene headlights have waterproof covers and the cylinder on the running board is the acetylene generator. The side-lights are oil. These wheels are easily detachable as is proved by the spare. Until this time it had been normal for wheels to be non-detachable so that a (often frequent) puncture involved removal of the tyre, mending of the tube, refitting it all and the re-inflation to around 60lbs per square inch, more than double today's tyre pressures.

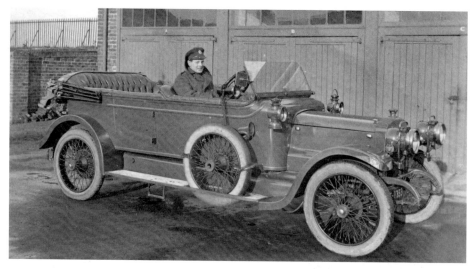

This is a postcard posted from "Will" serving at Chatham at Christmas 1918 to Mrs Besantio at Penryn in Cornwall. Will is still in uniform and the DAIMLER 20h.p. of c.1912 is still in very good condition, but as it has no War Office markings it may not have served in the War. The engine is a four-cylinder of 3.3 litres and with sleeve valves of course.

The torpedo body has nice horizontal lines but the parallel bonnet prevents the car having an overall one-piece appearance. The top of the windscreen is without a frame so the hood would have had leather straps to the side-light brackets. There are oil sidelights whilst the headlights are acetylene and "self-contained". The door-handles are inside the body and the step below the running board is a foot-scraper.

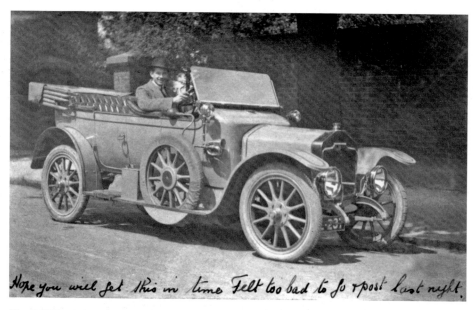

Hope you will get this in time Felt too bad to go rpost last night.

The ROVER 12h.p. four-cylinder of 2297c.c. was introduced in 1911. It was a successful model which also saw military service in World War One, but the authors suggest it is less than exciting to drive. This picture was sent as a postcard by Claude (the driver?) from Ramsgate to Margate in 1915.

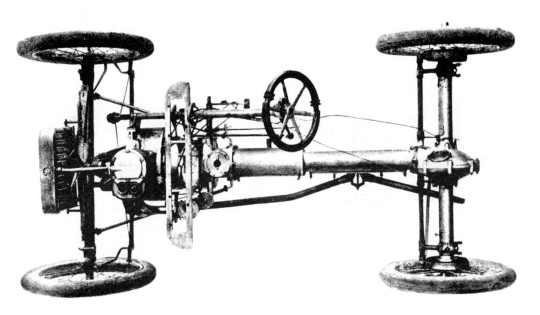

Above and below: The car is an 8h.p. ROVER single-cylinder and is a two-seater with fold-out dickey seat. 1912 was the last year of production which had started in 1904. Its most unusual feature was the tubular back-bone "chassis" incorporating the engine and gearbox at the front and the rear axle bolted rigidly at the rear. This must be one of the last cars of the series produced and has a Kent registration of late 1912.

The history of the photograph intrigues the writers. It was bought at Hershey, Pennsylvania. One would like to imagine a Kentish family sending this picture of themselves to a son who had perhaps emigrated and who they might never have seen again.

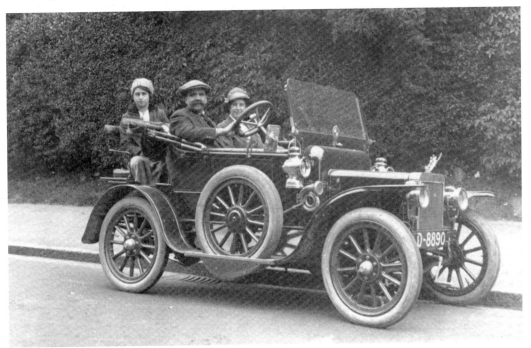

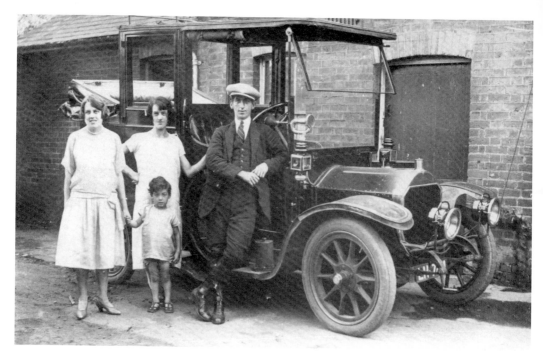

Here is a four-cylinder 15h.p. NAPIER landaulette registered in London in 1913. Napiers were made in Acton from 1900 to 1925. On the back of the card is written E.K. Webb, 100 Wickham Road, Beckenham., Kent.

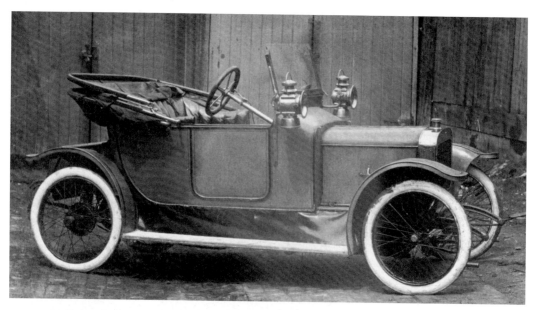

From Balsall Heath, Birmingham, hailed the AUTOCRAT, made from 1913 to 1926 and advertised as "The Aristocrat of Light Cars". This one is the 1913 8/10 model with a twin-cylinder engine. It seems to have been sold second-hand by a firm in Brixton in 1915 to S.H. Bailey of 18 Sutherland Road, Tunbridge Wells.

One imagines this postcard
was taken after the First
War showing a man who
may have been a soldier,
now in an invalid carriage.
The car is a two-seater
American STUDEBAKER
of 1913. It is the model
15/20 and painted blue.
It was bought new by
Allen Tatham, The Towers,
Westmoreland Road,
Bromley.

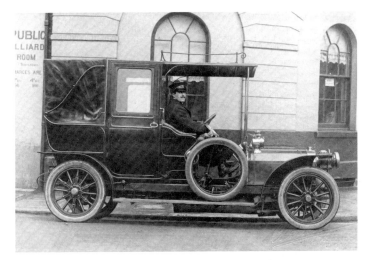

Middle and below:
In 1904 Frenchman
Georges Richard started
a new manufacture in
Paris with the intention
of having a single model
policy – thus the name
Unic! By 1906 UNIC were
making several models and
in 1911 this landaulette
is seen outside the Dover
Billiard Room.

The UNIC tourer is
a couple of years more
modern with smoother
lines, the fuel tank now
above the driver's feet
behind the bonnet, and
is model 16/24 owned
by Henry Noakes of
Brenchley.

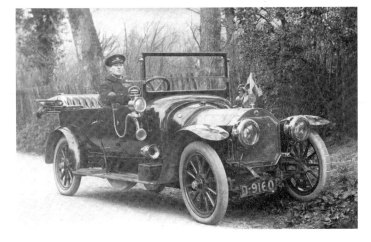

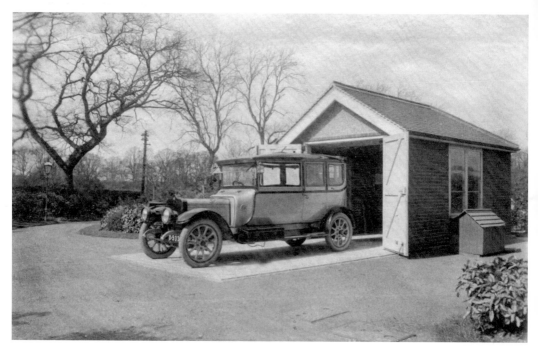

This is a 1913 25h.p. STANDARD registered in Kent as D 9334. Its finish was described as aluminium colour. The saloon body, by Vincents of Reading, has only two doors giving access to the rear. Front seat occupants would walk forward between the front seats, but this allowed very large front side windows. The motor-car garage was quite a new idea at the time, of course.

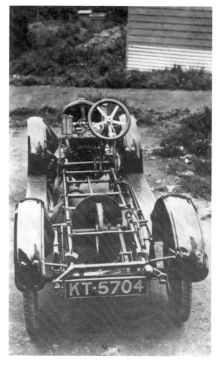

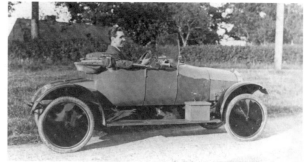

Left and above: The CRESCENT cyclecar was made in Walsall in the years 1911 to 1915. It may have looked like a small car but it had a, by then, archaic tubular chassis, air-cooled 2 cylinder engine and friction-drive transmission. The prop-shaft turned a big disc which drove another disc at right angles to it. The second disc could be slid sideways to give infinitely variable gearing and taking it across the centre gave reverse. This one has a water-cooled J.A.P. engine of 8h.p. and slightly domed wings dating it to 1915.

The second photo is this same car, showing how it looked when complete. It was bought new by Joseph Covington of Eynsford, and survives to this day.

Below: D.E.W.1913
This little car was made beside the gatehouse
of Lullingstone Castle, Eynsford. Called the
DEW or D.E.W. it was an ultra-light single-seat
cyclecar of 4½ h.p. though 8h.p. two-seaters
were also announced, both with belt-drive.

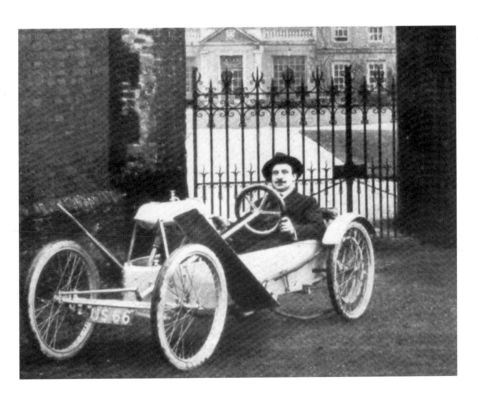

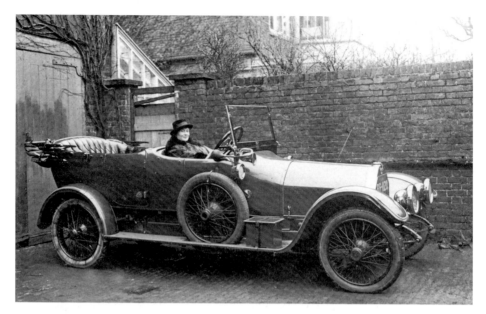

1914 was the last year of production for ARMSTRONG-WHITWORTH of Newcastle-upon-Tyne where the company was a leading maker of armaments and had interests in shipyards. The 20/30 was the large 4-cylinder car of 1914. An identification feature of the Armstrong-Whitworh is the low quick-release, water filler cap. Although registered in Newcastle this picture was taken by F. Scrivens of Checkley Studios in Herne Bay.

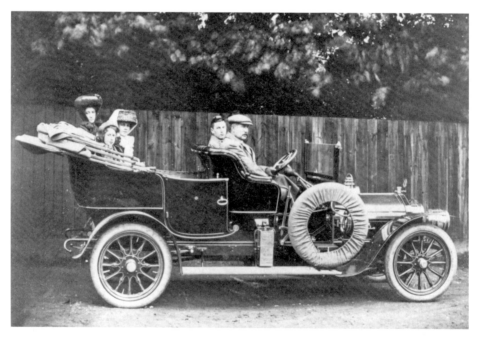

A 1911 WOLSELEY tourer first registered to Mr L.V. Gibson of Wilmington who is here seen with members of his family at East Wickham Farm in Welling. The body was built by Beadles of Dartford and was still owned by grandson David Gibson many years later.

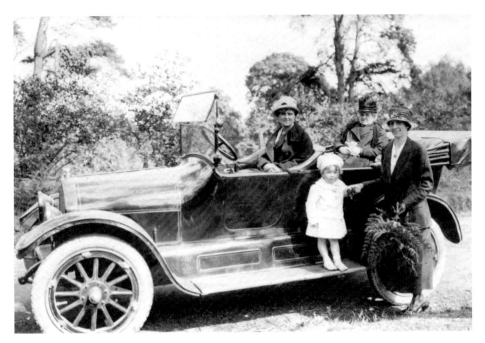

The postcard is taken at Petts Wood and the car is an OVERLAND, made in Indiana and registered in London (LM-8903) in 1914 though its appearance suggests a vehicle of about 1920.

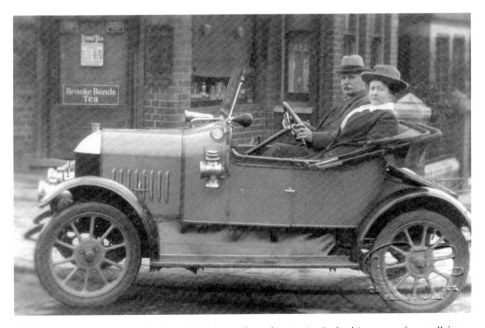

William Morris, later to be Lord Nuffield, started production in Oxford in 1913 of a small four-cylinder car with White & Poppe one-litre engine. The whole car sold (as shown here) for £175. This is a 1913/14 MORRIS Oxford but the presence of the tax disc which was not introduced until 1921 dates the photograph, which was taken in Folkestone, after the Great War.

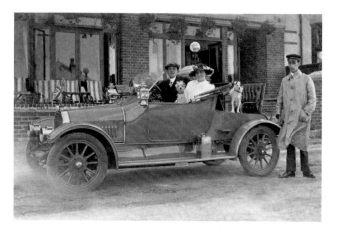

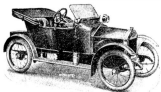

This page: SWIFT progressed (as did many early motor companies) from sewing machines, bicycles, tricycles and quadricycles to make cars from 1900. For 1914 three models were announced and above is one of the four-cylinder cars outside the Palm Bay Hotel, near Broadstairs. The chauffeur would have swung the car into life (as there were no starter motors in Europe until the early twenties) and then travelled in the dickey seat with the spare dog.

Below: A cyclecar had been made by Swift of Coventry in 1912 but for 1914 came the SWIFT LIGHT CAR which was similar but with a pressed steel chassis, two-cylinder 7h.p. engine and this one is painted grey. It was registered in February 1915 to Frederick Allen of East Cross, Tenterden.

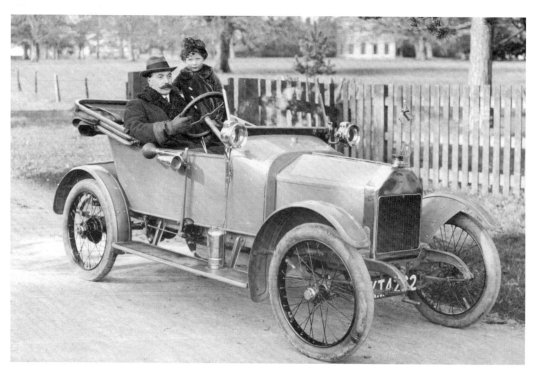

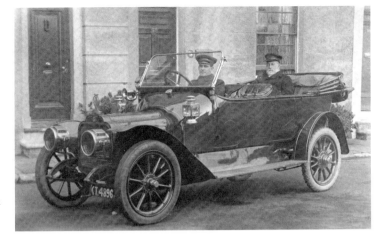

It seems improbable that a French 13.9 h.p. MORS from Paris could have been newly imported to be registered in Kent in 1915 during the War, but here it is, painted royal blue and owned by Philip Dawson of 37A Manor Road, Folkestone.

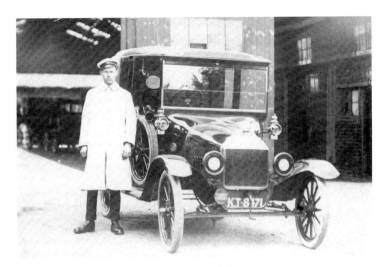

Middle and below: Above is a wartime FORD with English all-weather coachwork. The lamps are partially blacked out for the war-time. The car had a "Hackney Carriage" plate beside the number plate. It was registered to Geo. Marshall at the Royal Crown Hotel, Sevenoaks.

Below is another wartime "T" with landaulette body. The card photographed in Hythe has the comment "Archie Sharpe taken ill July 4, died July 14, 1918 and also "Y.M.C.A. car".

Both cars have electric headlights and oil side-lights and were made in the American Ford company's factory at Trafford Park, Manchester. Note the transverse springing and the wide track. All early American cars had to have a track of the same width as horse-drawn vehicles in order to fit America's deeply rutted, unmade, country roads.

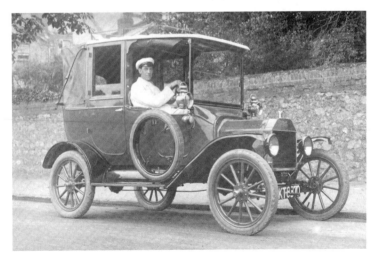

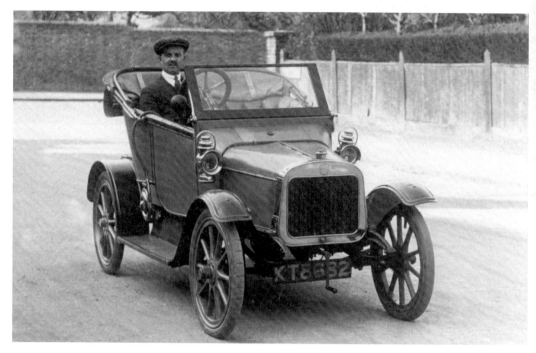

One wonders how such an ephemeral light car made in Burton-on-Trent came to be registered in Kent in 1916, the ACE of 8.6h.p. with very small monobloc four-cylinder engine.

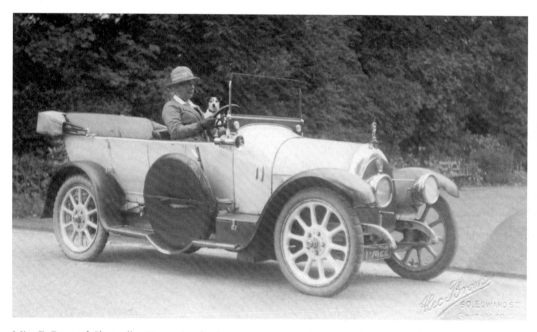

Miss E. Ross, of Chancellor House, Tunbridge Wells, purchased this FIAT 15/20 new in 1916, when motor car production in Europe had slowed right down. Seen here with her dog, she appears elsewhere in this book driving the Fiat in a peace procession.

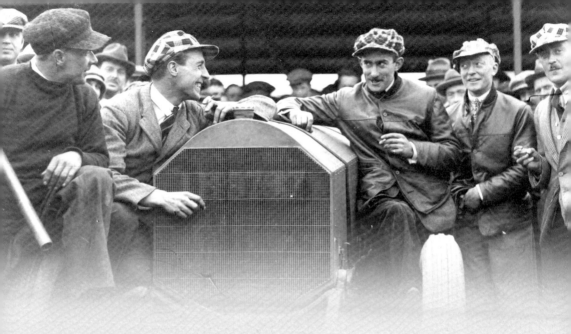

Chapter 2

Vintage and 1930s cars

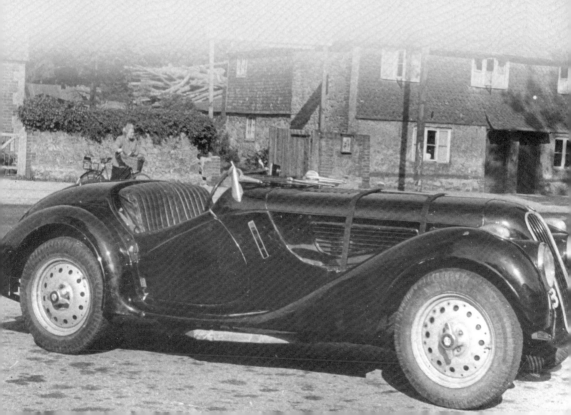

A real rarity from Smith & Milroy of Pond Garage, Orpington, of which only twelve were made in the period just after the First World War when so many companies tried to get in to the motor car business and countless men had come home from the conflict having just learned to drive. The two-seater 10h.p. ORPINGTON car had been displayed at the 1920 London Motor Show and was sold at £495 marketed as "The Businessman's Light Car".

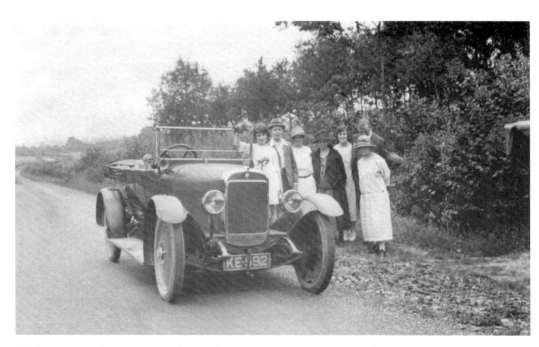

All the way from Dumfries in Scotland to be registered in Kent in 1920 is this ARROL-JOHNSTON 15.9h.p. tourer. Puzzlingly the card is date-franked "06" in Ramsgate over a ½ penny stamp of King Edward VII. The car was bought in September 1920 by Robert Geering of Bank Chambers, Ashford.

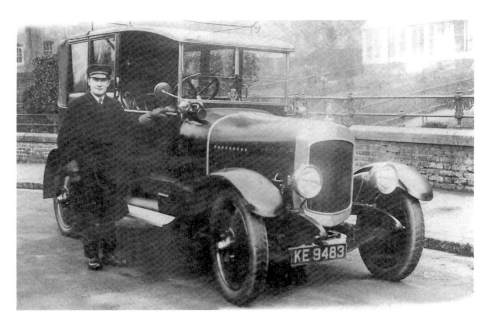

Another one a long way from home. VULCAN cars were made at Southport in Lancashire from 1902 to 1928. The company was better known for its commercial vehicles. A big management hiccup occurred at the end of World War One but this landaulette was new in 1921 to Mr C.W. Chitty, flour miller in Dover. It was of fairly stolid design and, like all Vulcans, its mascot was a blacksmith with his anvil (a "vulcan" of course).

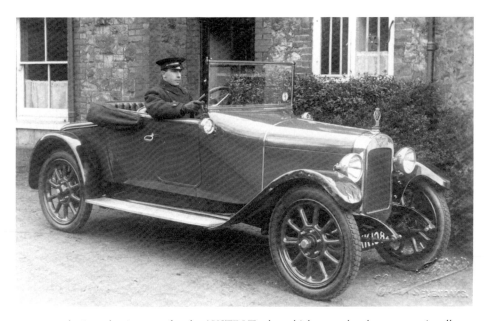

1921 was the introduction year for the AUSTIN Twelve which proved to be an exceptionally hard-wearing design and made in taxi form until the 1940s. We are surprised today to see a chauffeur in a car chosen as a two-seater by his master, though this one has two seats in the dickey. The majority of people could still not drive in 1921 and many cars needed some regular maintenance. What a smart turnout this is at a house in Sevenoaks.

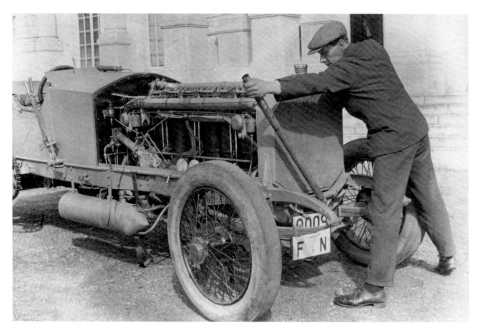

Above and below: The real car had only one Chitty and two Bangs. Ian Fleming's make believe had two Chitties and two Bangs!

CHITTY BANG BANG was created by Count Louis Zborowski of Higham Park, near Canterbury in 1921 and was the first of three Chitties to be built. It used an old Mercedes chassis fitted with a 23-litre Maybach aero engine. The Count was an Anglo-American and heir to part of the Astor fortune. He was a colourful competitor at Brooklands and his mechanics and entourage wore loud checked caps thought to have come from Palm Beach.

One could not start an engine of this size on the handle. Here the mechanic turns it over with a long metal bar to suck in the mixture, then the bar is removed and the engine switched on in the hope that it would fire. The second photo shows the man with the crowbar on the left and Zborowski with his foot on the axle. They are in front of the pits at Brooklands. Zborowski was killed racing in the Italian Grand Prix in 1924.

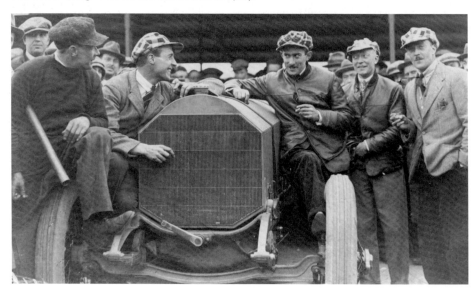

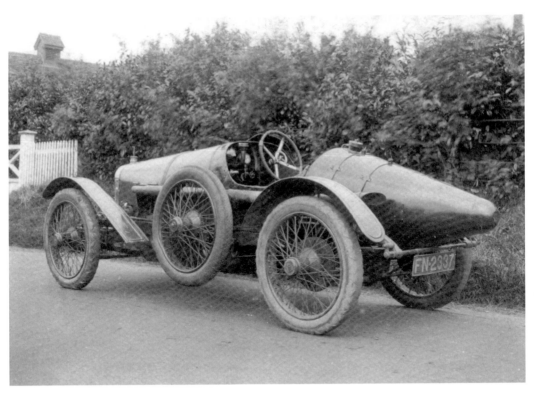

Above and below: FN-2337 is a Canterbury registration and the car is a 1912-13 Coupe de l'Auto racing SUNBEAM. It could have belonged to Count Louis Zbrowski in the early twenties.

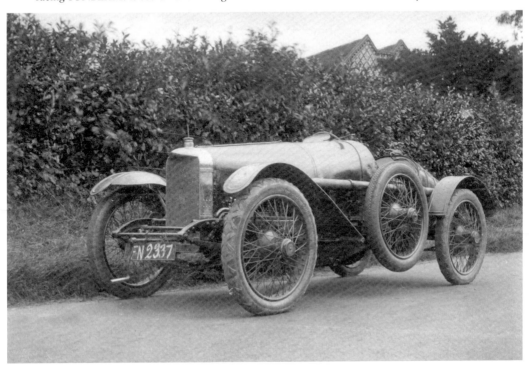

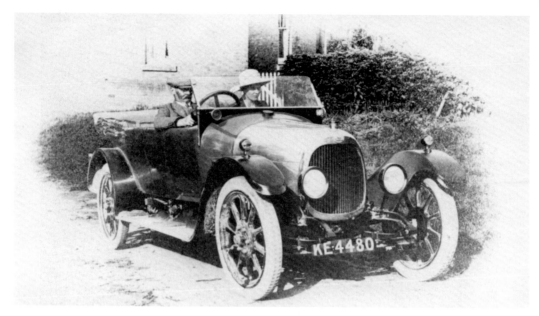

The Angus family had been coachbuilders in Newcastle for fifty years when this company started car manufacture (perhaps assembly was a more correct description) in 1919. This is a 1921 ANGUS-SANDERSON made in the year the company moved from County Durham to Hendon, Middlesex. This one has detachable Sankey wheels but many had disc-wheels which were waved rather than flat. The rear springs can be seen to be long cantilevers. The car was registered in April 1921 to Edward Collinson of Park Farm, Cranbrook, and survives to this day.

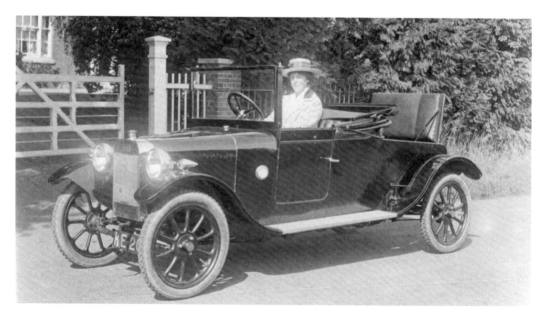

Here is Mrs Agnes Arnold in her 1920 LAGONDA 11.9h.p. Lagonda cars were made at Staines from 1906, moving to Feltham in 1947, Newport Pagnell in 1957 and lasted being made alongside Aston Martins until 1989. Latterly known for sporting and luxurious vehicles, at this period they only made light cars.

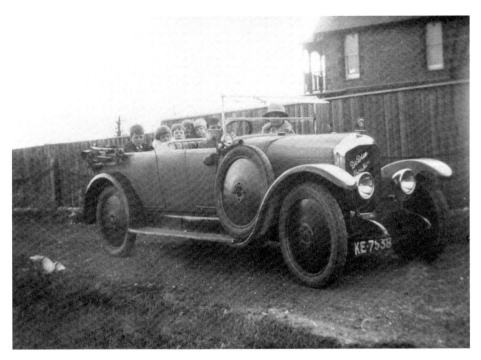

Six children and grandmother pose in a Kent-registered 1922 DE DION BOUTON tourer. The car looks big but is probably the 15c.v. four-cylinder and it is fitted with Michelin disc wheels. De Dions were made at Puteaux in France from 1883 to 1932.

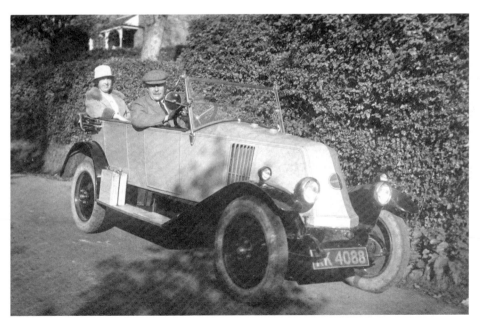

In 1923 the RENAULT had a new round badge. In 1926 this was changed to the diamond shape still used today. This is the model NN 9/15 with four-cylinders and 950c.c. It was the first model to have a smooth line of bonnet top whilst keeping the rear radiator.

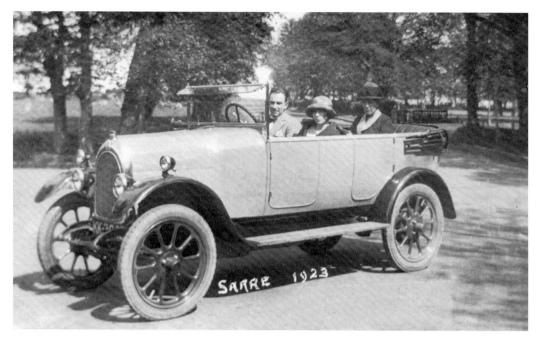

A new entrant into car making after World War One with high hopes but that did not result in quantity production. This is a 1923 BEAN 11.9h.p. a good but stolid car from Tipton and Dudley in the West Midlands. It is photographed at Sarre.

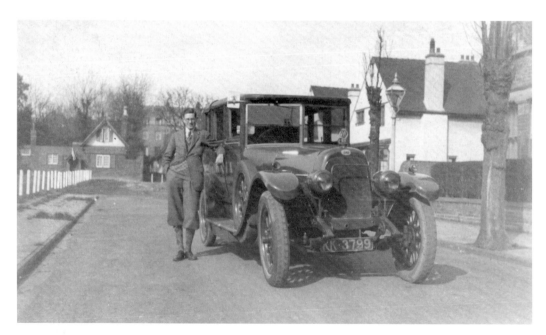

Mr L.H. Mortimer of Herne Bay poses proudly with his big FIAT, which he registered on 6 April 1923. The car is the model 510 of 3446c.c. and later cars of this model (1924/25) had front wheel brakes which were being widely adopted at that time. FIAT is an acronym of Fabbrica Italiana Automobili Torino.

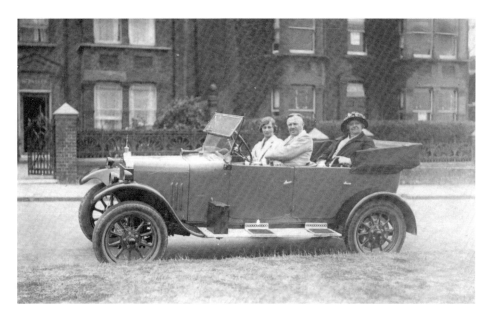

Captured by a Herne Bay photographer this is a circa 1923 V3 model STANDARD tourer. A note on the back of the card would suggest the occupier of the car was "superintendent for Burma Railway before the War".

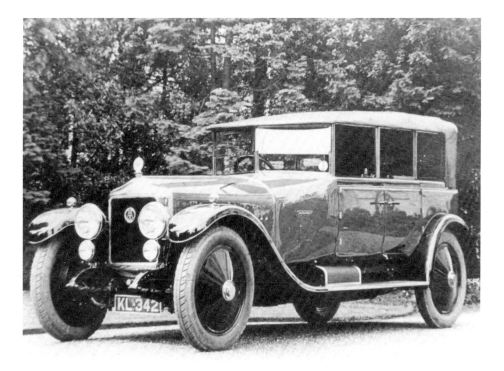

The MINERVA was a fine make from Belgium that lasted to the mid-thirties. This one has a transformable cabriolet body with V-windscreen. It is probably a 20c.v. and dates from 1924 when it was registered to W.E. Thorp of Beckenham.

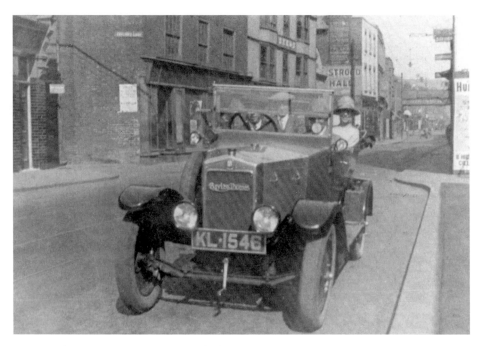

An unusual car made in Birmingham only during the early twenties. This BAYLISS-THOMAS is a four-seater with the polished aluminium bonnet that was a feature of the marque, with a 1,500c.c. Coventry Simplex engine. The car has a 1924 Kent registration and is photographed in the Rochester area. It was registered to Major Gray of Rainham.

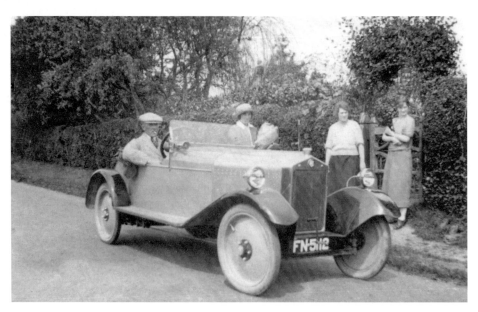

From Hersham, Surrey, came A.B.C. cars and motorcycles. The cars were always sporting although the earlier ones had rather frail engines. The 10/12h.p. had a horizontally opposed twin-cylinder air-cooled engine. The gravity petrol tank under the bonnet was filled via the "radiator" cap which caused trouble if garages filled it with water.

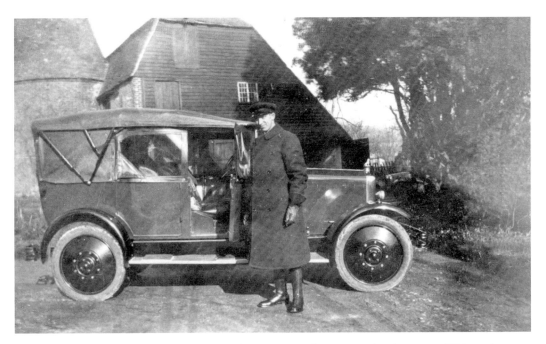

The ARMSTRONG-SIDDELEY was made in Coventry from 1919 after Armstrong-Whitworth acquired Siddeley-Deasy. The 14h.p. was introduced in 1923 with 1,852c.c. four-cylinder engine. This version was called the Cotswold tourer but here it is with a Kentish oasthouse behind.

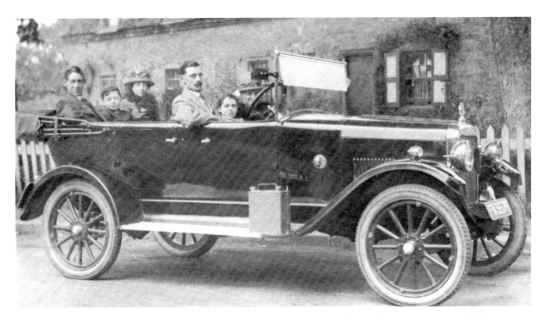

The American OVERLAND was imported very successfully in the early 1920s, but the British Government's McKenna duties on imported cars made it more economic for them to be assembled here, at Heaton Chapel, by Willys Overland Crossley Ltd. As time elapsed, more and more of the car was manufactured here. This is a 1923 example, but as with all the Canterbury-registered cars, no details are known of the owner.

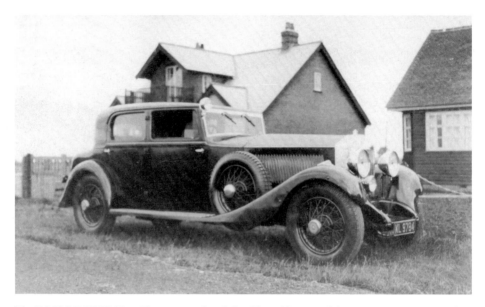

The ROLLS-ROYCE New Phantom replaced the Silver Ghost model (1907-1925) in 1925. The car with 7,688c.c. six-cylinder engine was to sell alongside the 20h.p. car of 3,127c.c. This very early New Phantom (chassis MC 8) was bodied as a saloon limousine by Martin Walter of Folkestone for W.H. Beckett of Folkestone. Many of these cars looked dated in the 1930s and were rebodied like this one to the order of London dealer Jack Barclay in 1935 and here seen after modernisation. From the introduction of the Phantom Two by Rolls-Royce in 1929 the New Phantom became known as the Phantom One.

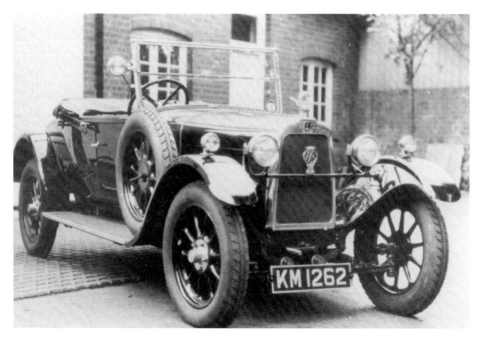

A 1925 TALBOT 10/23 or 12/30h.p. looking very smart but not yet sold with front wheel brakes. The lamps look a little weak if much night driving was envisaged.

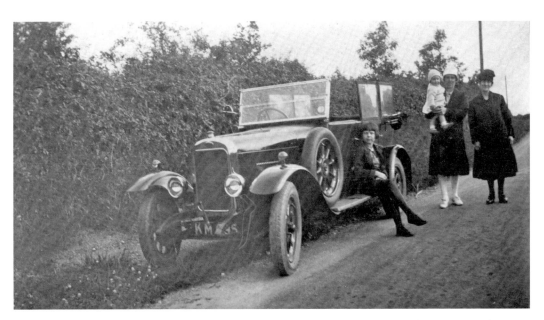

Clyno cars were made in Wolverhampton by a company already well-known for its motorcycles. Clyno started well with sales eventually reaching 12,000 per year but was overextended and had gone by 1929. This is an 11h.p. CLYNO tourer with a side-valve four-cylinder engine of 1,368c.c. and was sold in November 1925 to F.C.H. Brock of Tunbridge Wells.

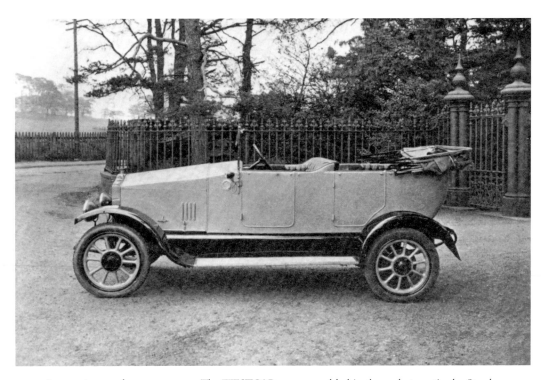

A rare picture of a very rare car. The WESTCAR was assembled in the early twenties by Strode Engineering Works at Herne, a company controlled by Major Charles Prescott-Westcar OBE.

How did this little motorcycle-engined, OMEGA, three-wheeler made in Coventry in penny numbers only between 1925 and 1927 come to be registered in Kent? The price new was £90.

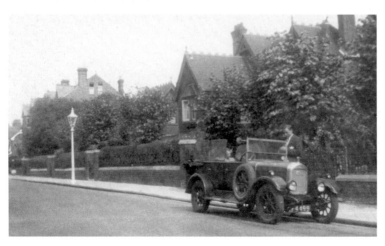

Middle and below: Two SINGERS of 10/26h.p., the upper one of 1925 having no front wheel brakes and ¼ elliptic suspension. The lower car, from the end of the model's production has front brakes and ½ elliptic springs. Both cars are tourers, the first seen at Whitstable and the second in Canterbury Road, Herne Bay, with the car owned by H.O. Wray of Wickham in 1935.

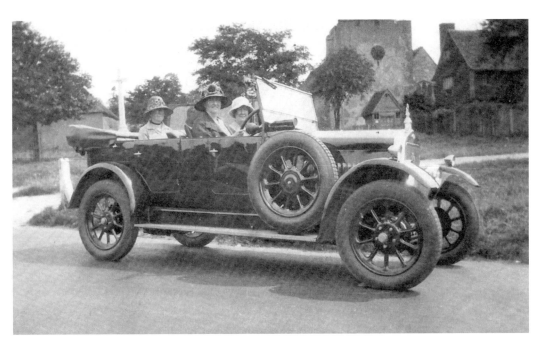

The village of Otford is the scene for these three hatted ladies in their *c.*1926 11/22h.p.h.p. WOLSELEY tourer. Dr Katy Williams is driving and she lived at Holmesdale in Otford.

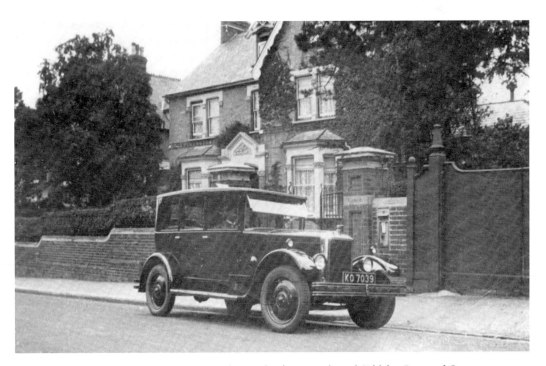

In 1919 two car-makers, Armstrong-Whitworth of Newcastle and Siddeley-Deasy of Coventry amalgamated to form ARMSTRONG-SIDDELEY in Coventry. This is a 15h.p. of 1,900c.c., built in 1928, presumably outside the Kentish home of the first owner, Mr G.H. Bannister.

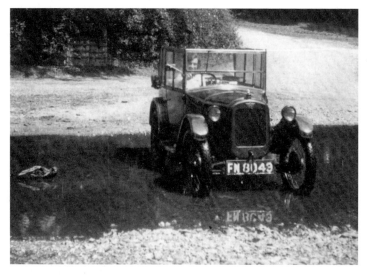

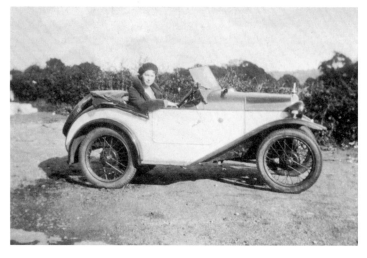

This page: First, two
little AUSTIN SEVEN
tourers, one Kent and one
Canterbury-registered.
"KO" still has the lights
on the scuttle and a
swallow mascot. "FN"
has the lights on the front
wings, the more modern
position. The "KO" car
was registered to C.B.
Durrant of Rochester in
February 1928.

The back of the third
photo tells us that this is
"Betty in Osbert". The
car is a 1928 AUSTIN
SEVEN. At that time
there were a number of
coachbuilders and firms
who thought they could
improve on the standard
product. This one is by
H. Taylor & Co. Ltd.
of Kensington who
produced a fabric-bodied,
two-seater, semi-sports in
dual colours. The sleek
bonnet was painted to
match. The doors of
this very small car were
specially shaped for the
feet to clear the door
frame. The windscreen is
V. There were removable
celluloid side panels and
a folding hood, which
matched the body colour.
The spare wheel lived
above the tail allowing
good luggage space in this
little car whose overall
dimensions were 4ft by
9ft 6ins long.

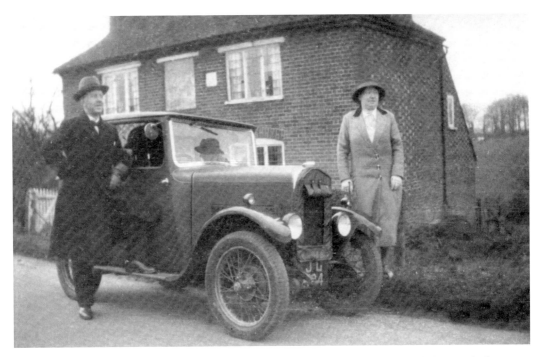

This is a 1929 TRIUMPH Super Seven saloon. The body is a Gordon England sliding roof saloon built on the Weymann fabric principle. The owners are believed to be from Rough Common, Tyler Hill, Canterbury.

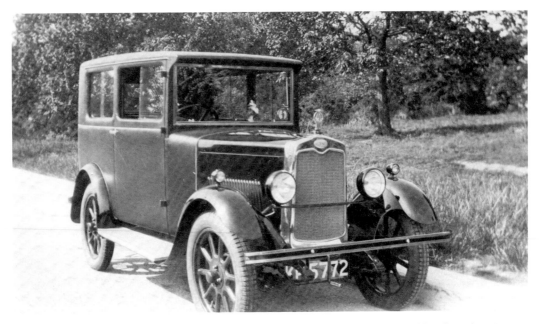

Right at the end of CLYNO production was this 9h.p. Weymann fabric saloon sold at £145 dropping to £112 10s. The factory closed in August 1929 just four months after this car was registered and just as the recession was beginning. Justly or unjustly the Clyno 9 has acquired a reputation as cheap and nasty.

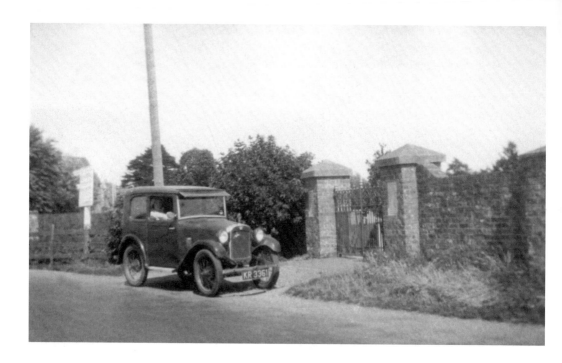

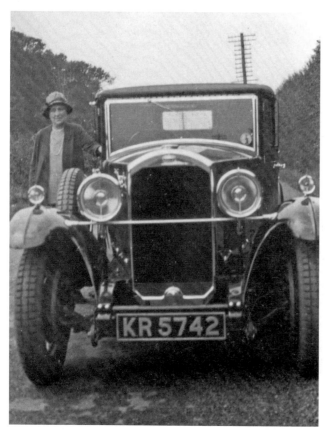

Above: A rather special 1930 AUSTIN Seven – it has a saloon body by coachbuilders Mulliners Ltd of Birmingham.

Left: Humber had started in both Beeston and Coventry in 1898 but Coventry only from 1908. This 1930 HUMBER 2.1 litre drop-head 16/50 six-cylinder is one of the first year's production after take-over by the Rootes Group, and registered to Mrs H.M. Clother.

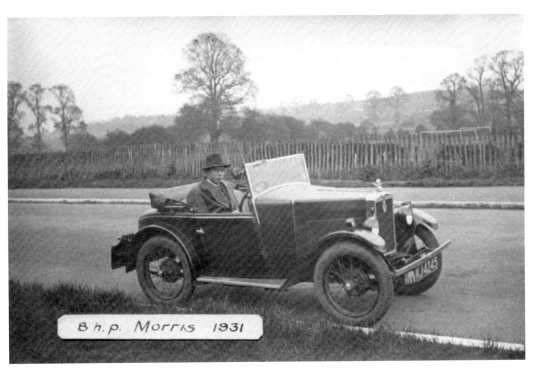

8 h.p. Morris 1931

This is a 1931 MORRIS Minor two-seater semi-sports. The overhead camshaft engine had a capacity of 847c.c.

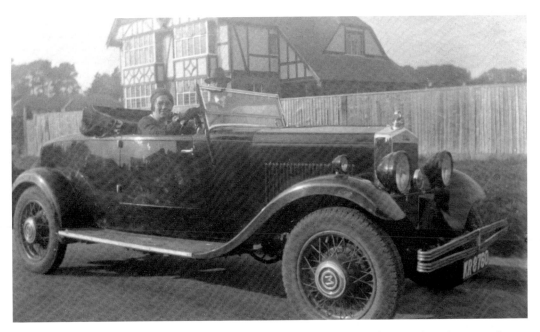

This early 1931 MORRIS OXFORD Six has a rare coachbuilt body of commodious but attractive lines built by Cunard of Acton. Later in 1931 Cunard were taken over by Stewart & Ardern, the London agents for Morris.

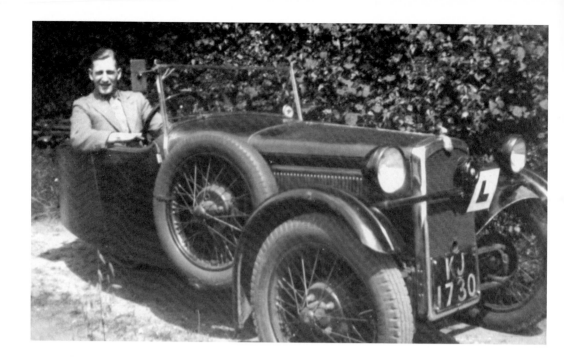

Above: Photographed in Chatham was this 1931 B.S.A. three-wheeler. It was made in the B.S.A. motorcycle factory at Small Heath, Birmingham and used a 1,021c.c. V-twin engine driving the front wheels which were independently sprung. In the centre of the front crossbar is the horn. The B.S.A. was said to be slower, but more comfortable and easier to drive than the Morgan three wheeler. Learner driver "L" plates were introduced with the Driving Test in 1935.

Left: All the details are here in this private advert circa 1948. This AUSTIN 10 was registered in London so has not moved far from home. In the late 1940s the demand for cars far exceeded supply. Those new cars that were being made were mostly reserved for export and there was not enough steel to supply the home market as well. The picture location may be Keston Ponds. Retreaded tyres are no longer permitted and petrol coupons no longer necessary.

Humber cars were aimed at the bottom end of the upper-class market and this is a Canterbury-registered 1934 HUMBER, either a 16/60 or a Snipe model. The chrome wheel-discs have been abandoned, and the car has a general air of neglect.

A SUNBEAM Twenty Five of 1934 with 23.8h.p. engine. This one was supplied new by Rock, Thorpe & Watson Ltd in Tunbridge Wells to Lloyd's underwriter T.A. Miall in August 1934.

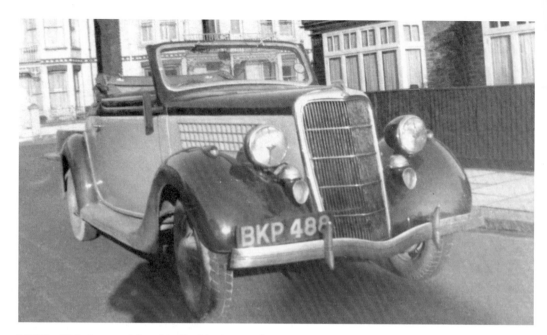

FORD of Britain moved from Trafford Park, Manchester, to Dagenham in 1931 and the decade saw more "European" cars produced, with great success. This is a 1935 Ford V8 with body that the Americans called a convertible cabriolet with rumble seat (dickey seat to us) and registered to W.A.C. Cooke in May 1935.

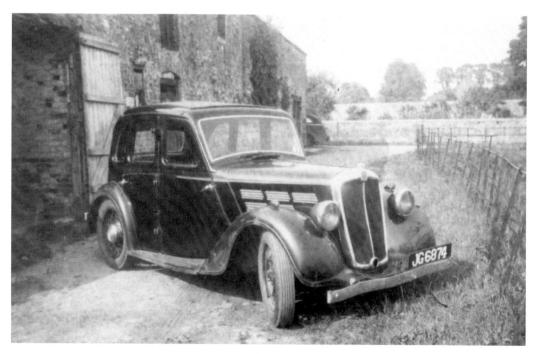

A 1936 Canterbury-registered MORRIS Ten Four Series II saloon. During the year the wheels were updated from wire, as at the back, to Easiclean as on the front of this car!

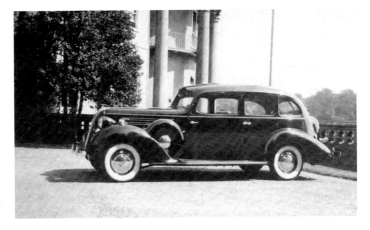

The HUDSON Eight Club saloon introduced in England in January 1936. It is photographed in 1939 outside the Sundridge Park Hotel, Bromley. Hudson cars, and their derivatives, Essex and Terraplane, enjoyed a considerable following between the wars in the UK.

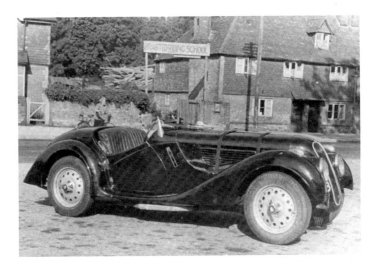

Middle and below: Brasted, east of Westerham, was the 1930s and 40s home of D.B. ("Bunny") Tubbs, motoring journalist, who was lent this FRAZER NASH-B.M.W. 328 for a holiday in about 1941. B.M.W. had introduced this six-cylinder, 2 litre, sports car in 1936. It was very successful. After the War the factory at Eisenach found itself in the Eastern zone of Germany so for the next ten years their cars were called E.M.W. rather than B.M.W.

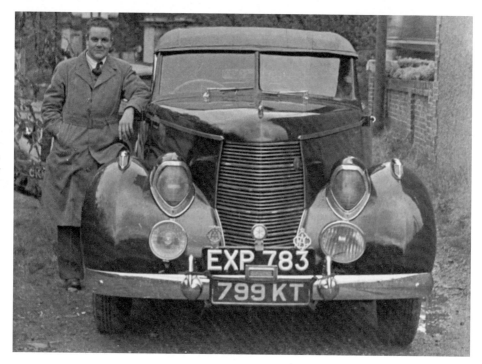

This is a 1939 American STUDEBAKER President convertible sedan with right-hand-drive registered in London. It is temporarily used with a garage "trade plate" issued by Kent County Council. 1938 was still not a happy time in America, which had been experiencing the depression since 1930/31. The engine was an eight cylinder. The fuel tank held 18 gallons (well over £100 worth today) and 1938 was the last year for the floor gear-change and for the inclusion of a drop head car in the Studebaker range.

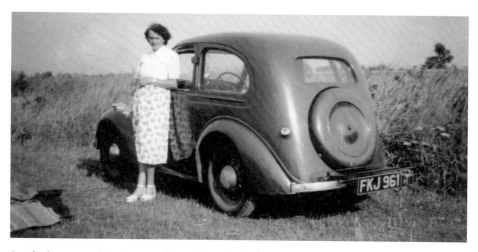

Standards were made in Coventry from 1903 but after World War Two we debased the prestige of "the British Standard" by labelling goods "standard" or "de luxe". Standard had taken over Triumph, also of Coventry, during the war so after the Standard Vanguard the products were Triumph.

There were no such problems in 1938 when this STANDARD two-door Flying Nine was made.

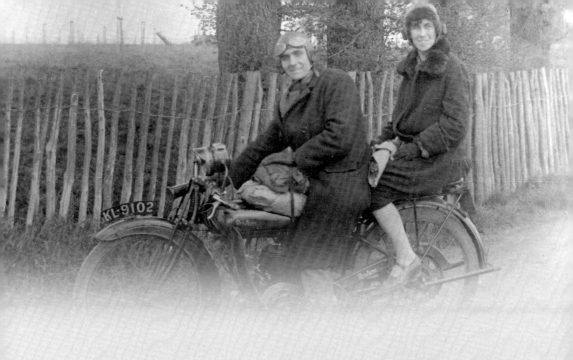

Motorcycles

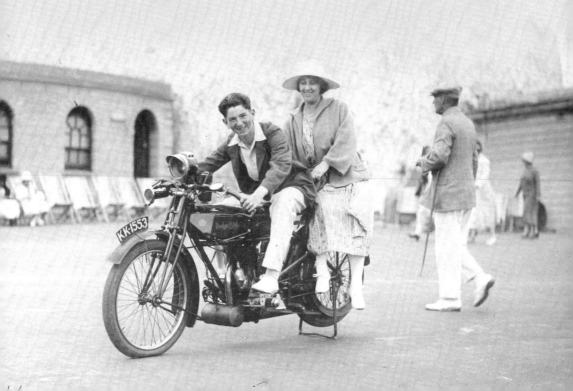

J.A.P. is a very familiar name in the motor-cycling world, but usually as a supplier of engines. This *c.*1903 belt-drive machine is a rare example of a complete bike built by J.A. Prestwich of Tottenham. It was registered by George Dryland of East Wickham. Note how the front number plate is fixed to the lamp (it can be lit up from both sides). Also, the luggage grid doubles as a stand.

In the early twentieth century the forecar, as shown here, had a brief span of popularity. This machine is an obscurity called a MOBILUS about which the authors know nothing, and, though bearing the Hastings registration number DY 100, was owned by Reuben Williamson of Prospect Road, Tunbridge Wells, and was new in July 1904.

This is an interesting picture of an unorthodox motor-cycle, the MIDGET BICAR. Its pressed and riveted sheet-steel frame is clearly visible and it also featured a variable pulley gear. The marque lasted from 1908 to 1912 and this 1909 3½ h.p. example was registered to Arthur Rogerson of Walmer.

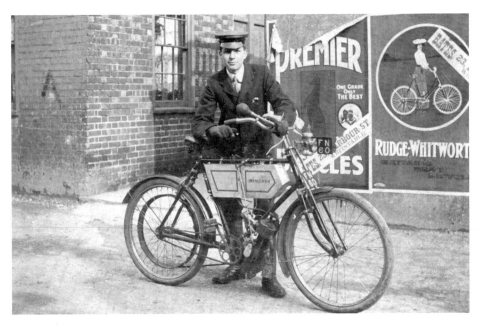

Photographed in Whitstable, with a nice backdrop of cycling posters, is a 1903 Belgian MINERVA motorcycle registered FN60 in Canterbury. At this date machines were little more than bicycles with engines clipped on and a tank hung below the crossbar.

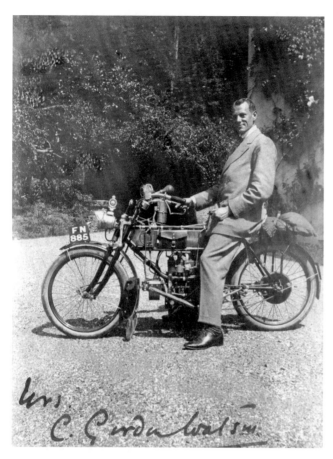

C. Girden Walsm

Left: Although this bike is registered in Canterbury (FN) there is some doubt whether it strictly has a place in this book: it is a Belgian FN (Fabrique Nationale) and the English importers often got personalised plates for them. It is a four-cylinder machine with shaft drive, and it will be seen that the magneto is mounted upside down.

Below: Raymond de Barri Crawshay of Sevenoaks owned this QUADRANT machine: it was photographed on 15 August 1909 at the Crooked Billet Corner, Southborough, after a collision with a Harrod's van. Damage to the bike is unclear, but the belt has snapped, and the offside pedal bent right back.

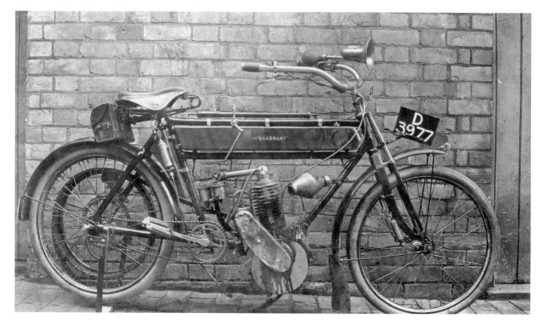

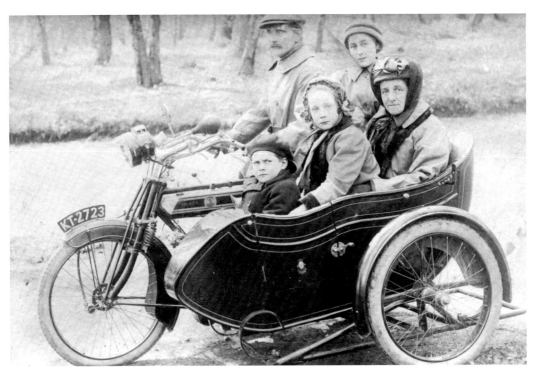

Above and below: These two lovely family portraits sum up how comparatively civilised the motorcycle combination had become by 1914. The upper picture shows a PREMIER 3½ h.p. owned by Robert Barker of Bromley, and the lower a B.S.A. 4h.p. owned by Charles Bannister, one of whose daughters seems to be sulking behind the sidecar because there is no room on board for her!

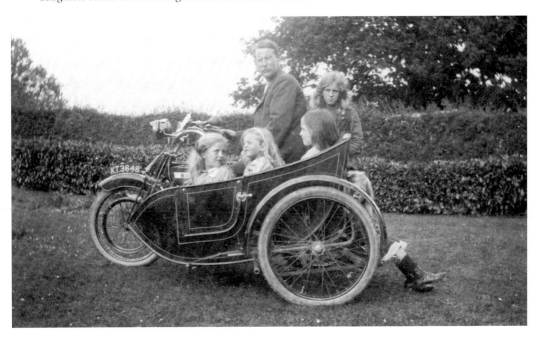

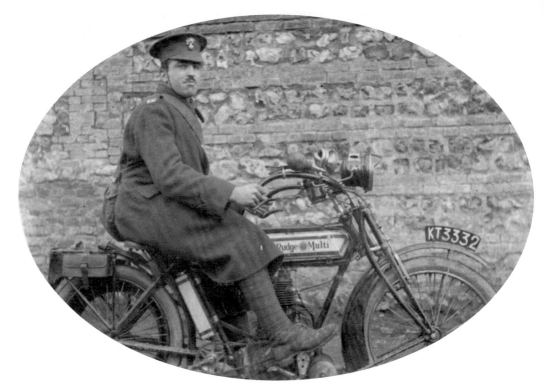

The motorcycle proved its worth during World War One, by which time it had become reasonably reliable. The War Office bought large numbers like this 1914 RUDGE Multi with its clever expanding-pulley belt drive which gave a large choice of gear ratio.

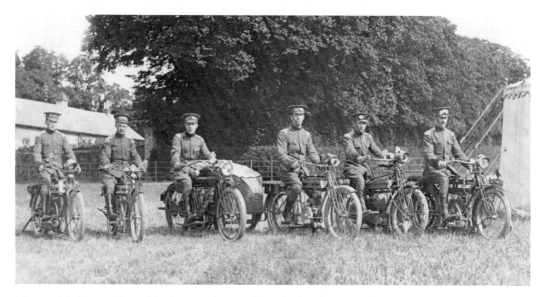

Not much is known about this photograph apart from the fact that it was the work of a Tonbridge photographer, and dates from the beginning of the First World War. From the left the soldiers are riding TRIUMPH, TRIUMPH, INDIAN, CLYNO, REX and BSA.

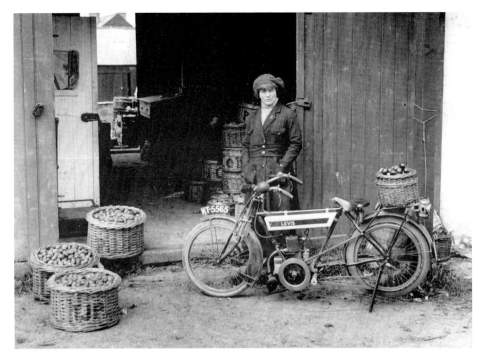

Above and below: These two delightful photos were taken in the autumn of 1915 and show Miss D. Clegg with her single-cylinder LEVIS motorcycle. She was employed by the Rural Development Co., during the First World War, and used the bike to visit farms, and to deliver pay packets to farm labourers.. She seems to have been well able to do her own maintenance.

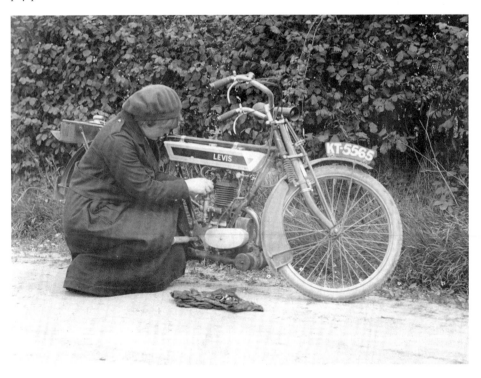

Shot at Herne Bay, this amusing picture shows a mock accident, with a bobby taking particulars. The expressions give the game away. The bike is an Oldham-built BRADBURY 3½ h.p. of 1917 which belonged to Stephen West of Whitstable.

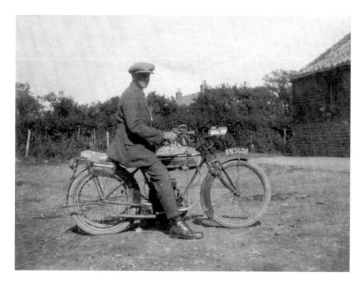

This NEW IMPERIAL J.A.P. 2¾ h.p. was first registered in 1919 to John Kingsmill of West Hougham Dairy Farm near Dover. However, the photo was taken in August 1926 by which time it may well have changed hands.

The Coventry marque of REX-ACME was a merger of two of the pioneer firms of British motorcycle building. This Blackburne-engined bike dates from 1925, when it was bought by R. Goldsmid of Sevenoaks.

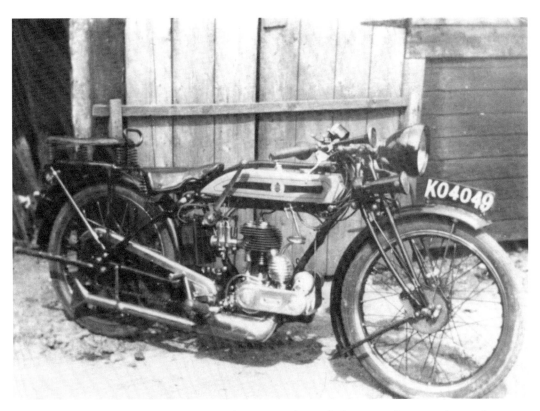

This page: How nice to have a photo of a bike together with the invoice for its purchase. John Hooker bought this TRIUMPH model Q from his local garage in 1927.

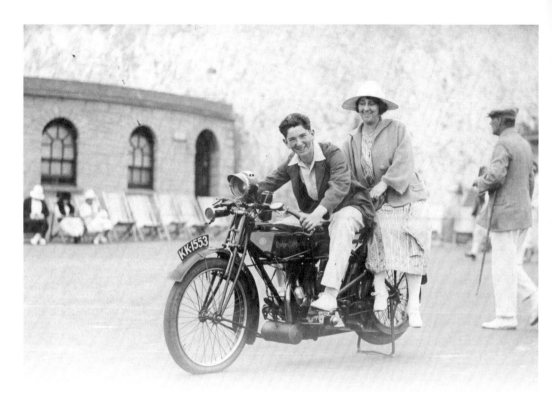

This page and above opposite: A ruse used by seaside photographers to get clients to pose was to provide a vehicle for them to occupy and thus pretend to their friends and family that they had got some wheels of their own. These bikes are (above) a RUDGE and (below) a DUNELT. Both are taken in Thanet resorts as is the MORGAN three-wheeler (opposite).

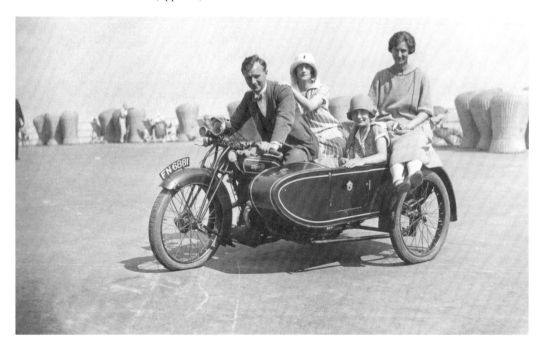

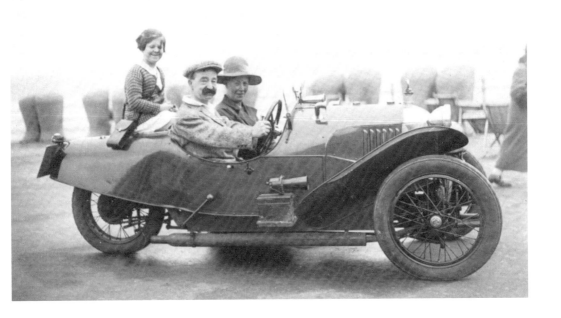

Right: Not ideal motorcycling gear, but perhaps this girl was just posing on her boyfriend's 1929 B.S.A. 2,50c.c. wedge-tank.

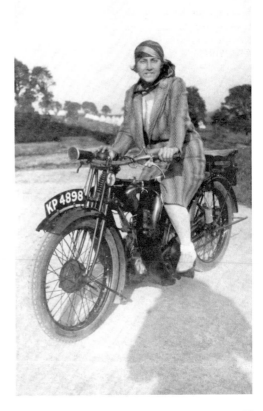

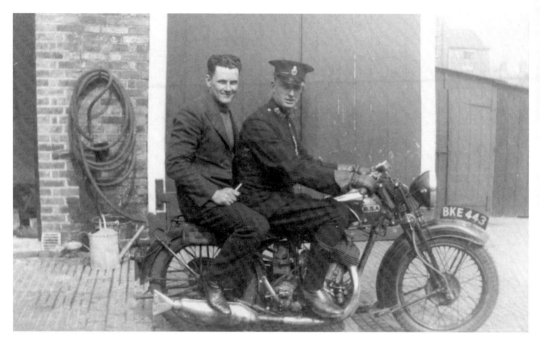

1934 is the date of this B.S.A., which belonged to Kent County Constabulary.

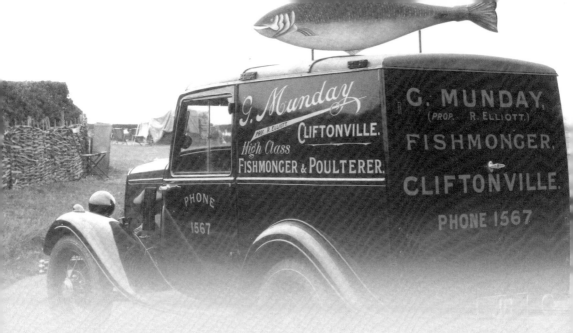

Chapter 4

Lorries and Commercial Vehicles

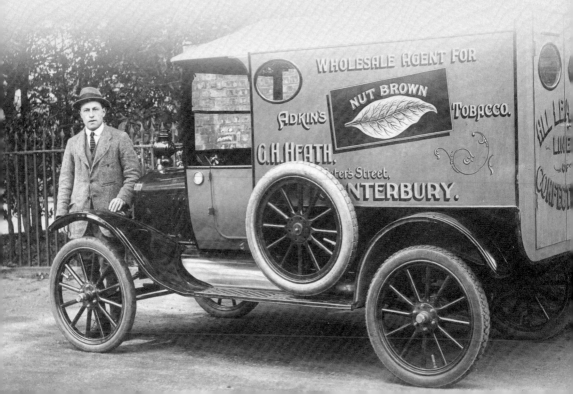

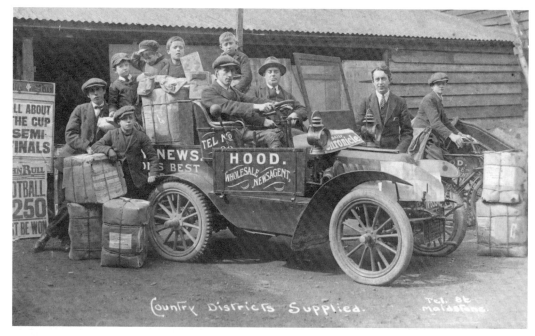

Above and below: In the early days of motoring, cars were often pressed into service, lightly adapted, to carry goods. Here are two early light cars doing work as newspaper carriers. The upper picture is of an 8h.p. DE DION BOUTON, well laden outside the Foster Street Warehouse of Hood's, Wholesale Newsagents, in Maidstone. Tom Hood is at the wheel, and Jack Hood is standing behind the bonnet. They evidently supplied papers to village stores. The lower picture shows a 1904 SIDDELEY 6h.p. belonging to W.J. Harris, Newsagent of Boughton, and was taken during the First World War.

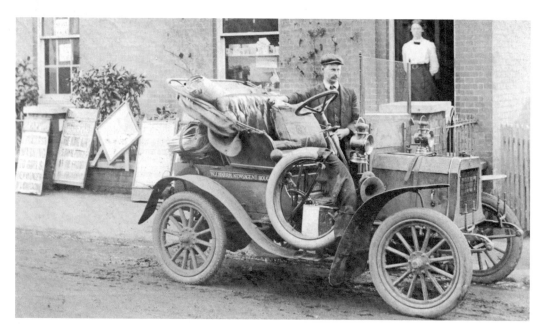

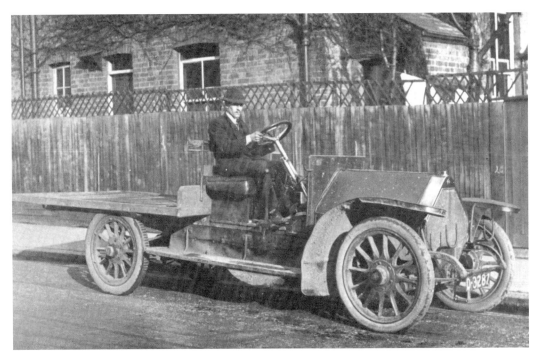

Often private cars lost their bodies in old age to become rough and ready trucks. This scruffy vehicle, an IRIS 35h.p., started life as a grand landaulette in 1907, belonging to George Joachim of Hawkhurst, but before it was finally scrapped it is shown with a flat-bed body. The Iris slogan, "It Runs In Silence", was probably no longer appropriate.

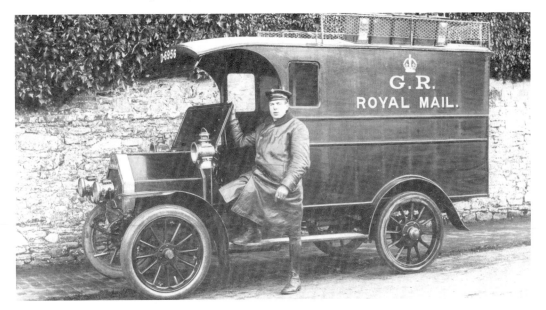

BELSIZE were pioneer manufacturers of cars and later vans, lorries and buses. The mail van shown here was purpose-built in 1911 on a 14/16h.p. chassis for James Miles, of the George Hotel, Cranbrook. At this date, mail vans belonged to local operators, not to the G.P.O. Note the petrol cans on the roof: petrol from pumps was not introduced until the early twenties.

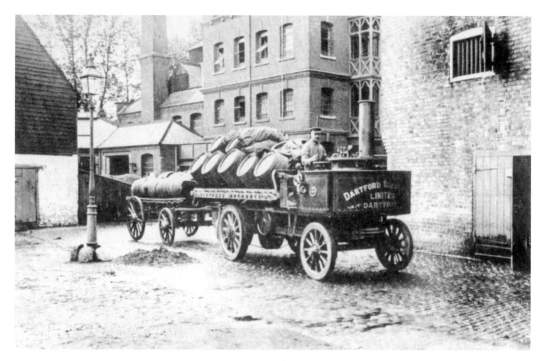

Above and below: Brewers often favoured steam when they switched from horse power and these two examples are both from Kent manufacturers. The upper one was built by JESSE ELLIS in Maidstone in 1903, and its unusual double frame can be seen: the lower one is a *c.*1920 AVELING & PORTER, built at Strood.

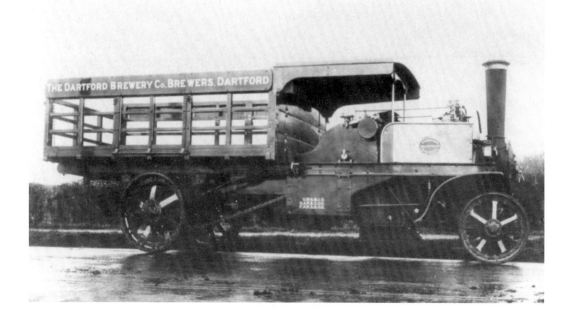

E.W. Philpot Ltd., Motor Engineers of Canterbury, ran this breakdown truck in the 1920s. The make is unknown, but it is of very sturdy construction and running on solid tyres, with twin rear wheels and bears a local trade plate.

SUNBEAM vehicles were popular as staff cars and ambulances during the First World War. An example of the latter, on a 16h.p. chassis and in Red Cross livery is shown with its lady driver standing proudly beside it, probably in Hythe. The registration mark, FN 3306, denotes Canterbury. Many of these vehicles were made by ROVER during the war.

After the First World War a large number of ex-War Department lorries were released on to the market and this DAIMLER Y type, belonging to the East Kent Bus Co., is typical. Its cargo is a mock-up of an aeroplane and apparently it was about to participate in a carnival at Herne. It followed a horse bus and a motor bus, which represented the past, present and future of transport. (photo supplied by the M.&D. and East Kent Bus Club, from an original in the Company collection).

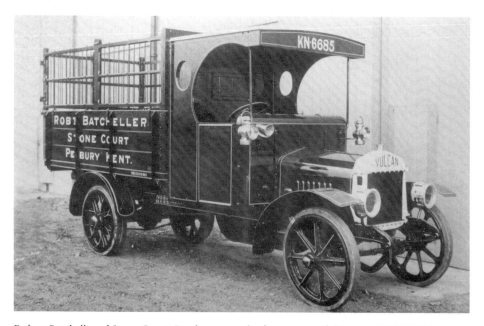

Robert Batcheller of Stone Court, Pembury, was the first owner of this 1919 VULCAN lorry. Solid tyres were still common at this date, but one might have expected electric lights. The bodywork was constructed by Beadle of Dartford.

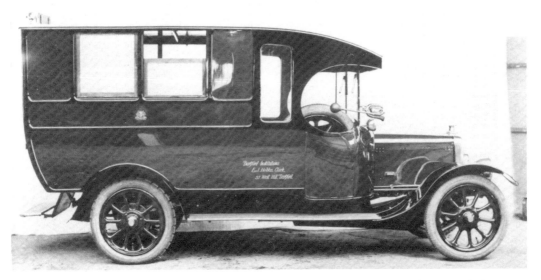

A TALBOT 25/50 chassis provides the base of this Beadle-bodied ambulance of *c.*1920. The lettering reveals that it was built for the Dartford Institutions. Rather curious is the positioning of the spare wheel, inside the bodywork to the right of the driver.

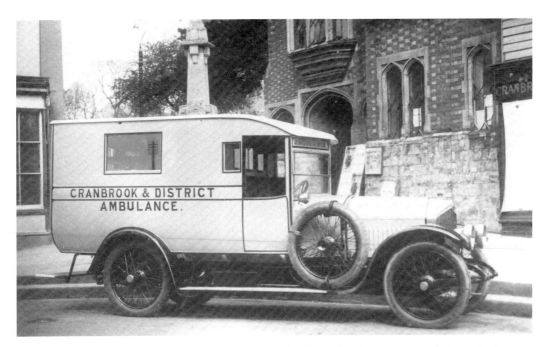

Parked by the entrance to the parish church is the local Cranbrook & District ambulance. Dating from the early twenties, it is on a CROSSLEY 25/30 chassis. Crossley, a Manchester company, had a reputation for sound engineering and good performance, both desirable for an ambulance!

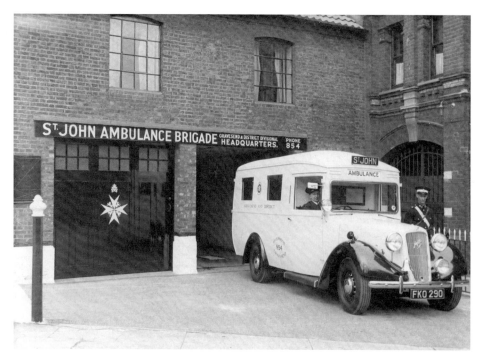

Registered in January 1939 was this AUSTIN 16 or 18h.p. ambulance belonging to Gravesend & District St John Ambulance Brigade. It would appear to be almost new in this picture. Unusual is the signpost lamp in front of the driver, very useful on a dark night for finding house numbers.

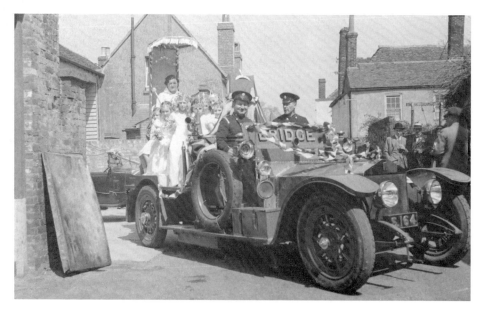

This ROLLS-ROYCE 40/50 Silver Ghost started life in 1910 with a Barker landaulette body, the property of an M.P. This picture, taken between the Wars, shows it converted to act as the Bridge fire engine, but here off-duty to carry the Carnival Queen.

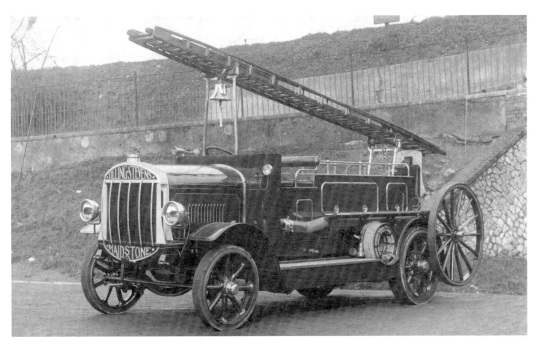

TILLING STEVENS was a Maidstone-based manufacturer, as the radiator advertises. The date of this splendid fire engine is unknown but is likely to be in the early twenties. It is photographed at the works, and has still to be lettered, so its ultimate destination is uncertain. The radiator is set so far forward that the dumb irons do not protrude at all.

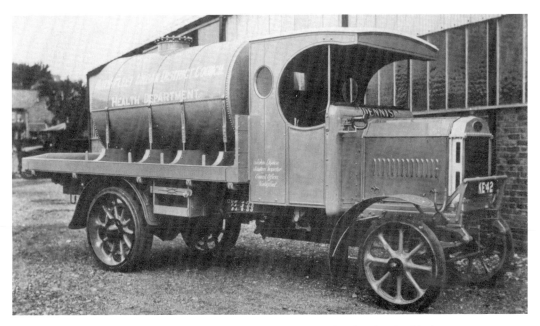

Northfleet Urban District Council operated this DENNIS tanker for their health department: its precise purpose is not clear, though it was probably used for cleaning drains. The hoses have yet to be fitted. It dates from 1920.

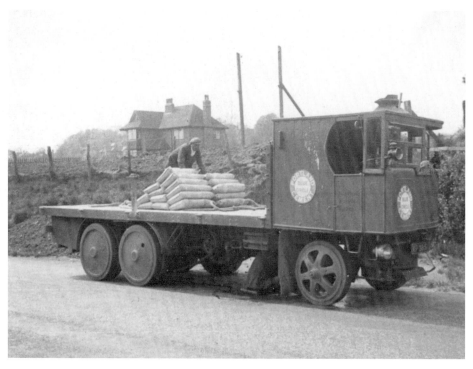

Steam-propelled lorries held their own for heavy load carrying until the early thirties, when changed taxation made them uneconomic. GARRETT, of Leiston, Suffolk, built this 1928 undertype wagon for Portland Cement. It is seen at Canterbury at work in May 1935.

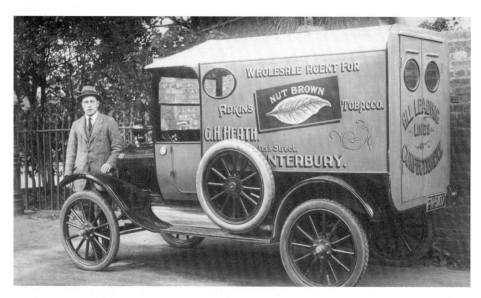

The first really affordable light van, suitable for tradesmen was the FORD Model T, which for countless small businesses, consigned the horse and cart to history. This 1922 example, still carrying oil sidelights, served G.H. Heath, confectioners and tobacconists of St Peter's Street, Canterbury. The sign writing is a real work of art.

An English rival to the Model T, and equally unconventional, was the TROJAN, in this case about to be delivered to a dairy. It is noticeable that, although the engine is under the floor, only a small part of the wheelbase is available for load-carrying compared with the Ford. Solid tyres were standard on Trojan utilities until 1932. The underfloor engine was a horizontal 1½ litre square-four, two-stroke with paired combustion chambers.

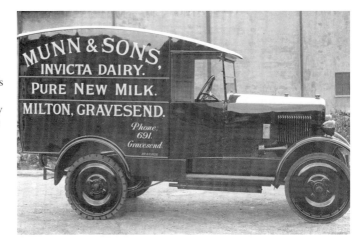

This MORRIS Cowley van was of more conventional design for the small tradesman and was extremely popular. The head and side lamps are combined on the front wings, and the driver lacks the protection of side windows. As Morris agents, Beadles naturally ran an example for their own use.

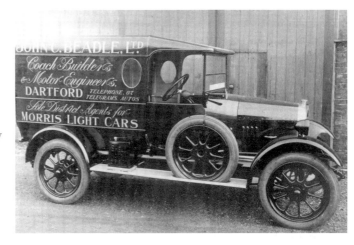

It was left to AUSTIN to produce the first really small van and this 1926 example belonged to the Singer Sewing Machine Company's Bromley store. It was just possible to fit a treadle-operated sewing machine inside. Still there are no side windows!

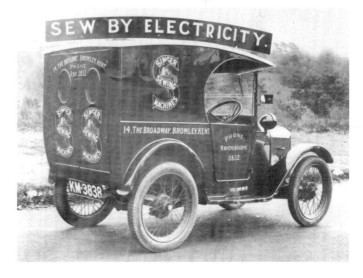

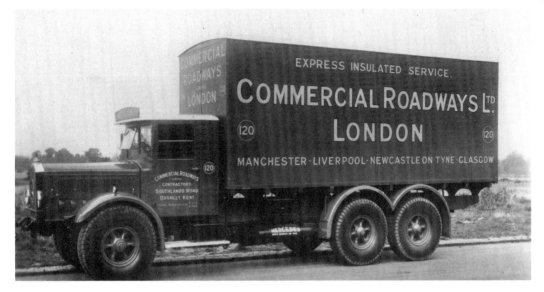

Diesel-engined MERCEDES-BENZ lorries began to be imported around 1930, but never made a great impact on the British market. This massive example belonged to Commercial Roadways Ltd, whose office was in Southlands Road, Bromley.

There is an interesting letter with the photograph, on Mercedes-Benz headed paper. Part of it reads:
"As you see, I am now with Mercedes, have been with them about four years ...
They are of course the fastest standard cars built, tho' I'm not so keen on speed now as I've had a couple of bad smash-ups. Also I started and am also now a big noise in our family transport company, photo enclosed of one of our fleet, and am actively engaged in forming another company, all of course at Bromley... Yours as ever Eric."

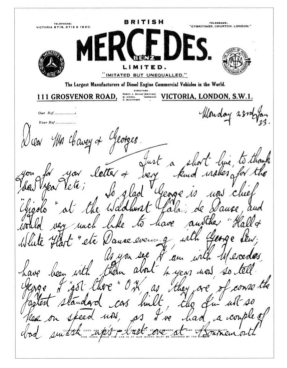

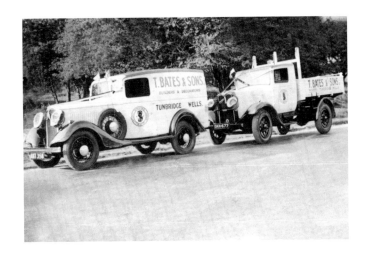

T. Bates & Sons, builders of Tunbridge Wells, have parked their BEDFORD van and COMMER lorry on the Common in 1935. They are waiting to take part in a procession, possibly to mark George V's Silver Jubilee, to judge by the flags.

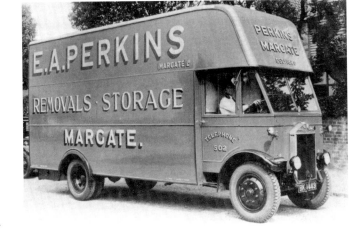

BKJ 449 is a 1934 ALBION furniture van, probably a model 473, belonging to Perkins of Margate. The caption on the card interestingly reads "Regular service London and Thanet".

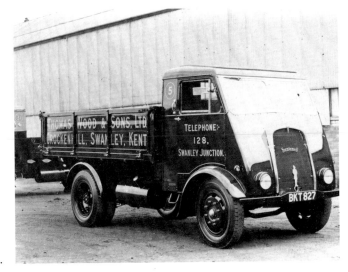

This lorry is a real rarity: badged as a Sentinel, but more often known as a GARNER-SENTINEL, it was the outcome of a merger of those two firms, and built at the Shrewsbury works whence came the famous steam wagons. It featured an engine/gearbox which could be extracted on built-in rollers when the front cross members and grille were removed. This example dates from 1935, and was no. 5 in the fleet of Thomas Wood & Sons, the well-known contractors of Crockenhill, renowned for their steam ploughing business.

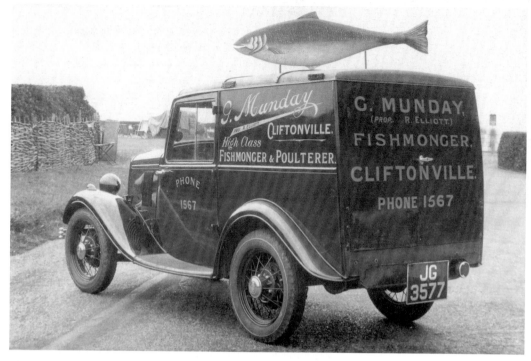

This very ordinary little FORD 8 van has become a head-turner because its owner, G. Munday of Cliftonville, has mounted a large fish on the roof. It is somehow reminiscent of Monty Python.

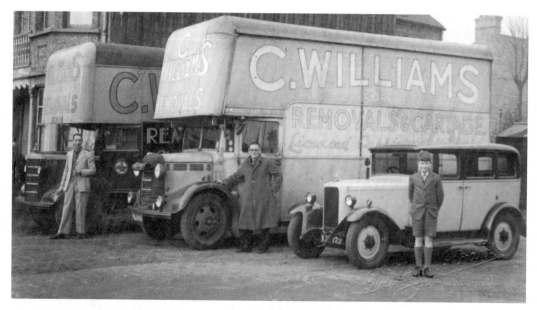

We close this section appropriately with a picture of a BEDFORD removal van belonging to C. Williams of Bexley or Bexleyheath, registered on 3 September 1939, the day World War Two commenced. This photo was obviously taken later, as the paintwork looks rather tired. The car in the foreground is an ARMSTRONG-SIDDELEY.

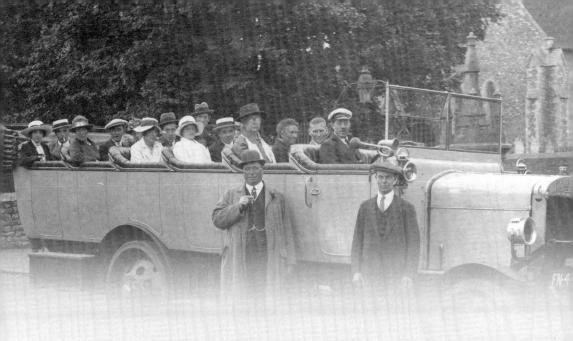

Chapter 5
Buses and Coaches

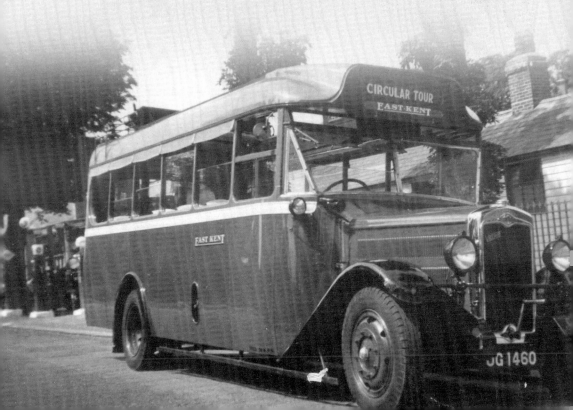

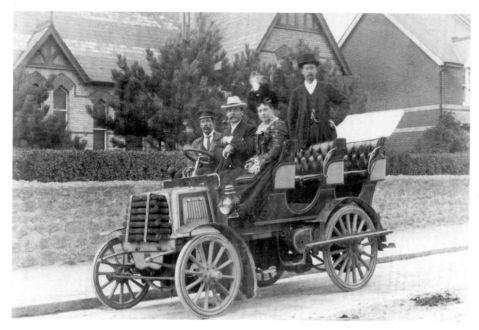

Little is known about this vehicle apart from what is visible in this picture by a Kentish photographer. It is a c.1900 chain driven MMC or DAIMLER (the two makes were very similar). A distant forerunner of today's people carriers, it features a panel behind the rear seat like an aerofoil, designed to protect passengers from the swirling dust, which smelled strongly of ammonia from the pulverised horse-droppings.

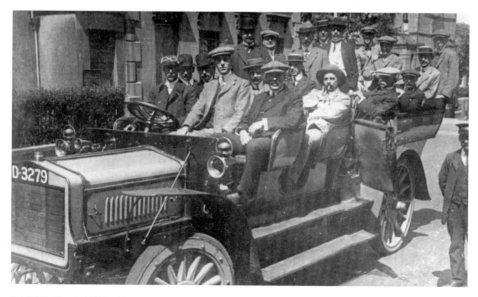

LACOSTE et BATTMANN were a French company who produced few cars under their own name, but sold components or complete cars to other companies. Commercial vehicles, however, did bear their name, and this 40h.p. charabanc was registered to Folkestone Motors in 1907. Solid tyres meant an uncomfortable ride, so the passengers would have hoped the driver observed the 12 m.p.h. speed limit to which the vehicle was subject.

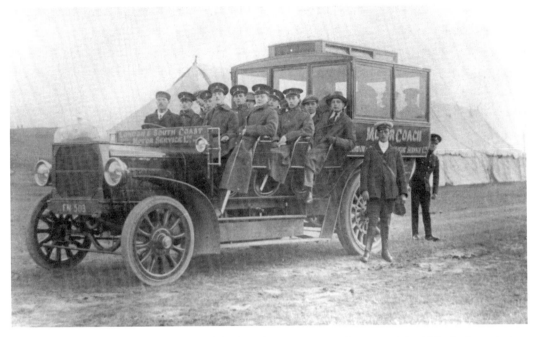

The THAMES Ironworks of Millwall built both private cars and commercial vehicles in the period prior to World War One. This rather unusual bus was built on a 35h.p. chassis in 1906 and operated by the London & South Coast Motor Service, and here is seen carrying a party of guardsmen. As was often the case, one front passenger sits outside the driver.

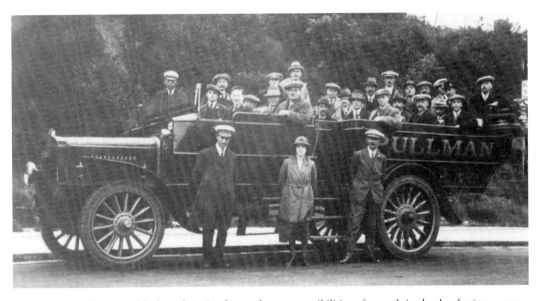

John Maltby was a blacksmith in Sandgate who saw possibilities of growth in the developing motor trade. By 1912 he was building buses like the one shown, and the body-building work continued into the late thirties. The body on this MALTBY chassis is unusual: described as a Pullman, it does not have a door to each row of seats and must have featured a central gangway. It is not therefore a charabanc. Folkestone Motors Ltd, took delivery of this impressive vehicle in April 1913.

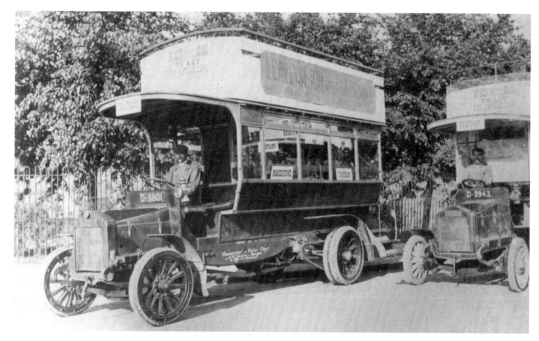

Commercial Motors of Maidstone was founded in 1908 and commenced operations on the Maidstone-Chatham route with these two HALLFORD 34-seater vehicles, built by J.&E. Hall of Dartford. 1908 was comparatively early for double-decker buses.

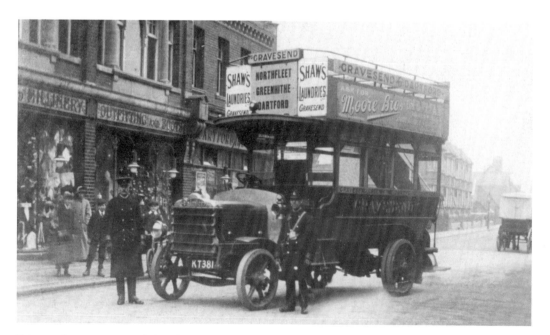

It is not always appreciated that the DAIMLER Company, famous for luxury cars, was once a substantial producer of commercial vehicles and buses. This picture shows a 40h.p. bus delivered to Gravesend & Northfleet Electric Tramways Ltd, in August 1913. It was finished in a livery of lake and cream.

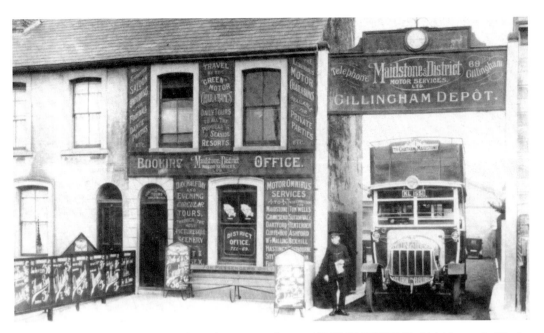

This very atmospheric photo from the twenties shows a TILLING-STEVENS of Maidstone & District Motor Services waiting, driver at the wheel, beside their Gillingham depot. The front of the booking office is almost totally covered by advertising. (Picture supplied by the M.&D. and East Kent Bus Club, from an original in the Company collection)

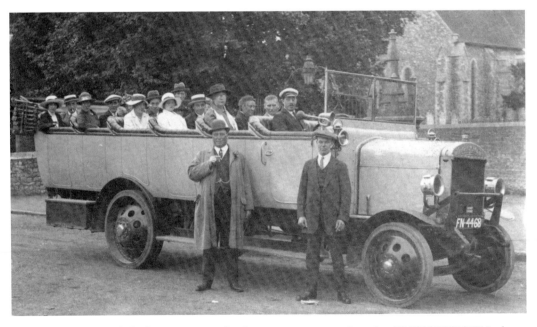

A very respectable looking party pose for the customary group photo in a THORNYCROFT J of 1920, belonging to Redbourn & Sons of Ramsgate. Could the bowler-hatted man holding a cigar be Mr Redbourn? Motorists complained that charabancs were difficult to overtake, and the absence of any rear-view mirror on this example gives one reason why.

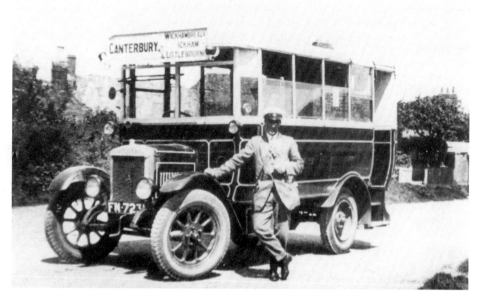

The East Kent Road Car Co. Ltd, was formed in 1916 as a merger of five companies, and was based in Canterbury. This picture shows one of their smaller vehicles, a MORRIS 1-ton chassis with East Kent's own bodywork. It was new in 1925 and is here shown serving the villages of Wickhambreaux, Ickham and Littlebourne, east of Canterbury.

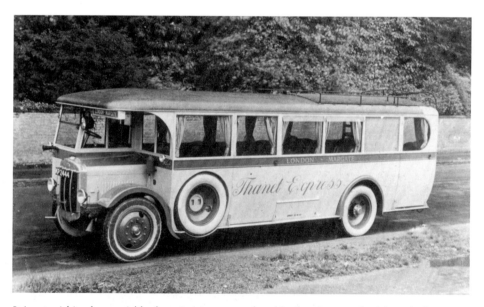

It is astonishing how quickly the primitive, uncomfortable charabanc evolved into the luxury coach. This is a particularly smart example, a 1928 TILLING-STEVENS B10 A2 coach, with Vickers body, operated by Thanet Express (the trading name of the Redbourn Group). This chassis started life as a works demonstrator for Tilling-Stevens. Immediately noticeable are the recessed spare wheel, the white-wall tyres (in need of a lick of paint) the curtains and the elegant lettering. It operated the London-Margate route, but was restricted to a tedious 20 m.p.h., which was in any case the national speed limit at the time.

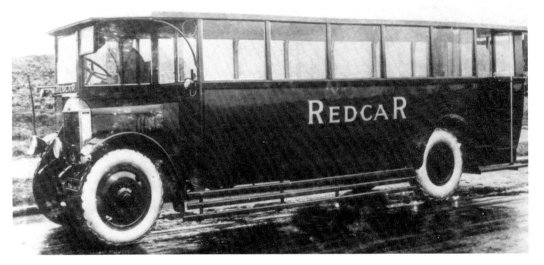

The Redcar Company was based in Tunbridge Wells, but was taken over by Maidstone & District in 1935. This photo shows a Scottish-built ALBION PM28, with body by Vickers of Crayford, which was new in 1927.

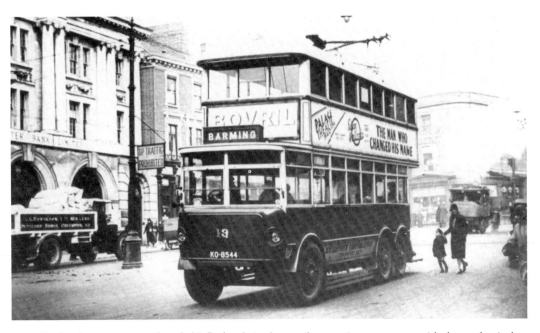

Trolley-buses are remembered chiefly for their almost silent motion, a contrast with the mechanical row created by many early commercial vehicles. Seen here in Maidstone, and being pursued by a smoky Sentinel steam lorry, is a 1928 RANSOMES operated by Maidstone & District Transport Department.

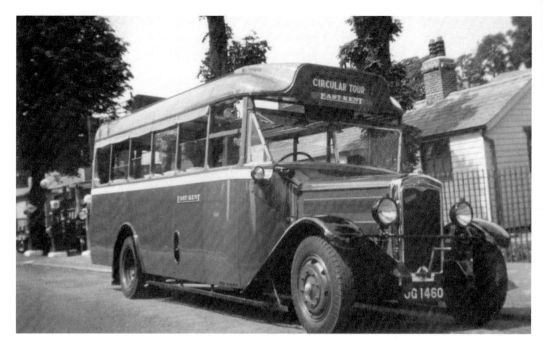

The bonneted style of bus was soon to lose favour when East Kent took delivery of this MORRIS COMMERCIAL Viceroy coach in 1931: although quite a long vehicle, it only seated twenty passengers. It is seen here in Hythe, while on a circular tour.

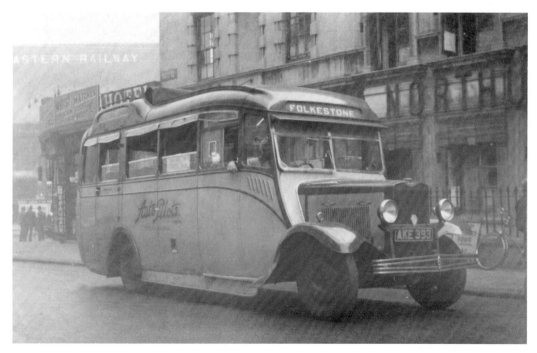

AKE 393 is a 1932 COMMER Centaur Coach owned by Auto Pilots of Folkestone. The twenty-seat body was built by Duple. An unusual feature is the front bumper.

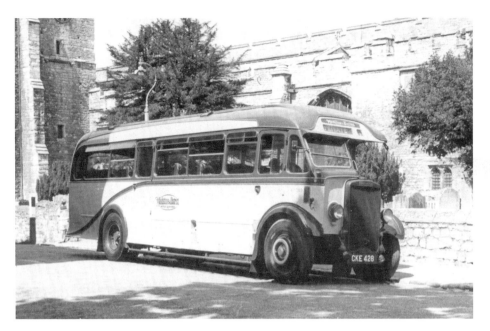

A LEYLAND Tiger TS7 coach of Maidstone & District demonstrates how much more efficiently the half-cab design used the available space. This smart and elegant vehicle dates from 1935 but would not have looked outmoded twenty years later.

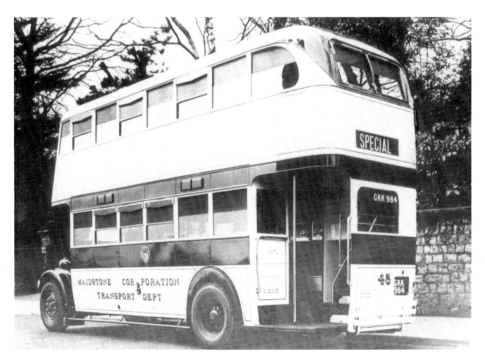

From this angle it is impossible to deduce the chassis manufacturer of this double-decker, but it is in fact a Manchester-built CROSSLEY Mancunian, one of four purchased by Maidstone Corporation in 1940.

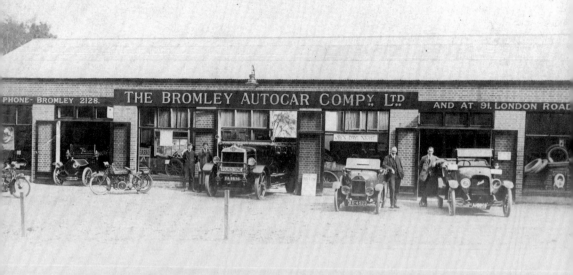

Chapter 6
Garages

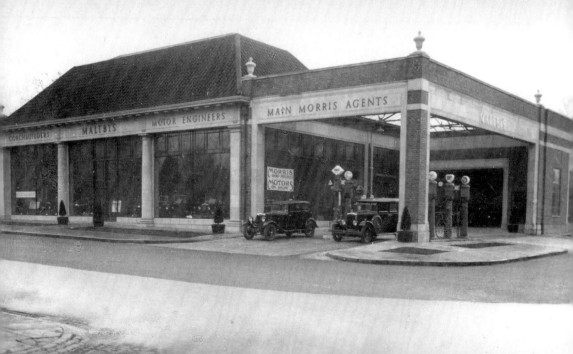

Like so many village enterprises of 100 years ago, Tippen's of Marden combined a number of trades. The Post Office premises, which also housed watch-making and stationers' businesses has been extended to provide a workshop and showroom for his cycle and motor-cycle agency. A crowd of small boys has posed for the camera, no doubt each dreaming of when he would possess a motor-cycle. A poster in an upper window advertises Premier machines.

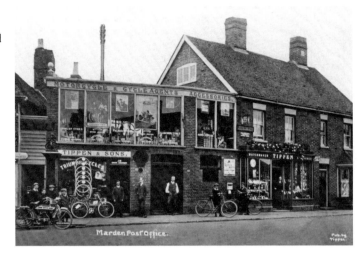

Marden Post Office.

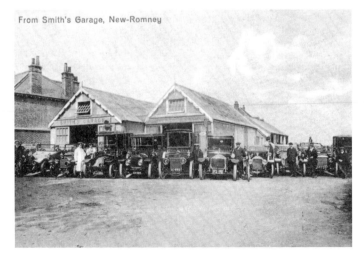

LANDAULETTE FOR HIRE.

Telephone 203, Maidstone

Open and Closed Cars for Hire.

Cars Stored and Repaired.

Accessories.

Tyres in Stock.

THE EARL STREET MOTOR CO.
(BEHIND THE ROYAL STAR HOTEL), MAIDSTONE.

The wording on this postcard from 1909 suggests that the RENAULT landaulette shown was just one of a fleet of hire cars operated by the Earl Street Motor Co in Maidstone.

From Smith's Garage, New-Romney

There is a fine line-up of good quality motorcars outside Smith's Garage at New Romney, including CHARRON, VAUXHALL, DAIMLER and NAPIER. Since many of the registrations are not local the cars may be those of visitors staying in the area. At this time (c.1912) petrol was still sold in cans, hence the absence of pumps.

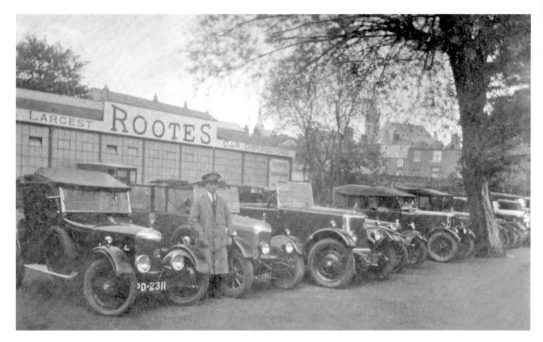

From the small beginnings of a motor business in Hawkhurst, Rootes Bros rose to become the world famous manufacturers of Hillman, Humber, Sunbeam and Singer. At the time of this photo, *c.*1928, they were running a large and prosperous garage in Mill Street, Maidstone. The line-up here shows (left to right), AC, MORRIS Cowley, ARMSTRONG-SIDDELEY, WOLSELEY and MORRIS Cowley.

This Tunbridge Wells garage advertising card (with a map on the reverse) must date from the early twenties to judge from the makes of vehicles cited.

By the early 1920s, when this picture was taken, the more ambitious garages had purpose-built premises with showrooms. The Bromley Autocar Co., agents for Waverley cars, had premises in London Road and also these premises shown in Bromley Hill. As well as two motor-cycles there are (left to right) a HUMBER, an AEC charabanc (the Crimson Rambler), a SWIFT 10 and a MAXWELL, with the proprietors standing between the later two vehicles.

Keeley & Green's premises at Langton Green are typical of many village garages between the wars. The petrol price per gallon in each case ends in three farthings, a marketing ploy copied today with 99.9p per litre. In those uncongested times it mattered not that the motorist could not park off the road to fill up.

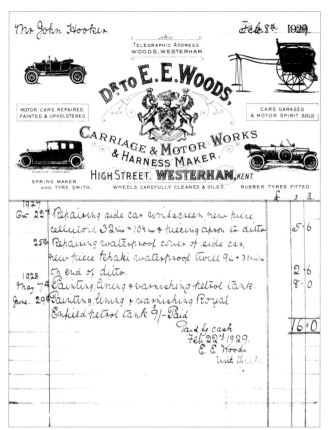

Left: The letterhead of E.E. Woods of Westerham testifies to their versatility: they catered for horse-drawn vehicles as well as cars and could cope with body repairs and upholstery besides mechanical problems. The date is 1929.

Below: A.&B. Garages Ltd of Ramsgate have mention elsewhere but here they display two Silver Ghost ROLLS-ROYCES. The nearer car dates from 1912 and is a landaulette by coachbuilder Hamshaw of Leicester. The other car is an all-weather of early twenties date with a most unusual forward-extended windscreen presumably for use in the rain. The photograph probably dates from about 1930 when the value of these cars was much reduced but their quality remained, making them ideal for hire work.

ROLLS ROYCE HIRE SERVICE.

A. & B. GARAGES, Ltd., RAMSGATE. Phone 4

F. H. Treacens
Photo

This rather bleak forecourt is the Long Reach garage at Whitstable. The pumps dispense Shell, B.P. and National Benzole. A CROSSLEY is parked by the small shed where, presumably, repairs are carried out.

It was garage premises like this, littered with unsightly signs, which prompted a national campaign in the late 1920s to tidy up forecourts. A MORRIS Oxford and AUSTIN 12/4 are at the pumps of the Woods Filling Station, Cliffe, run by G.T. Kearsey. Note that the Austin is being filled with fuel via the driver's door, the petrol tank being under the front seat.

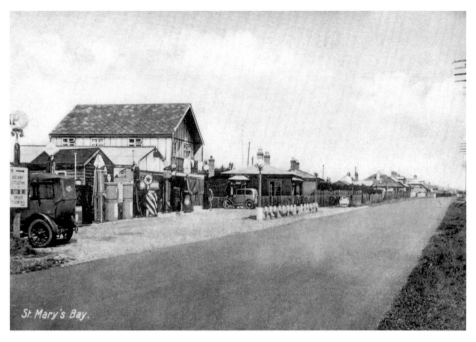

This unprepossessing and anonymous filling station is at St Mary's Bay. A Gordon England-bodied Austin 7 is parked in the furthest corner.

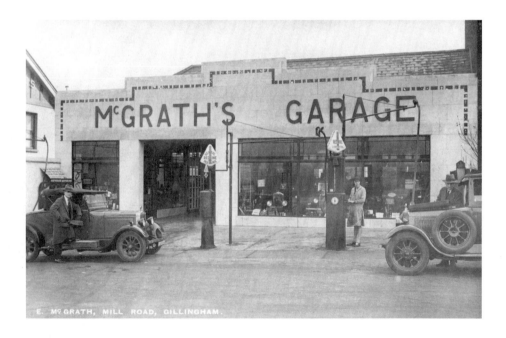

McGrath's Garage, in Mill Road, Gillingham, occupies smart Art Deco premises, the effect being slightly spoilt by the rather grubby-looking lady pump attendant. Two MORRIS Cowleys face each other and a SINGER and MORRIS Minor may be seen in the showroom.

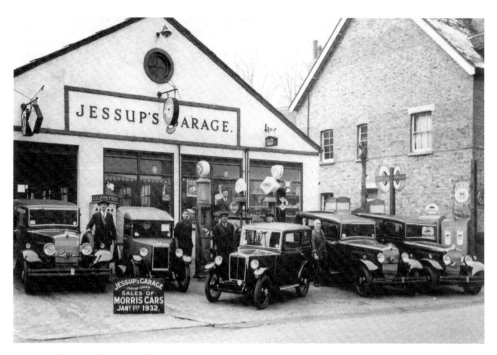

Jessups Garage of Dunton Green, north of Sevenoaks, were MORRIS agents, and here they display the 1932 range outside their premises.

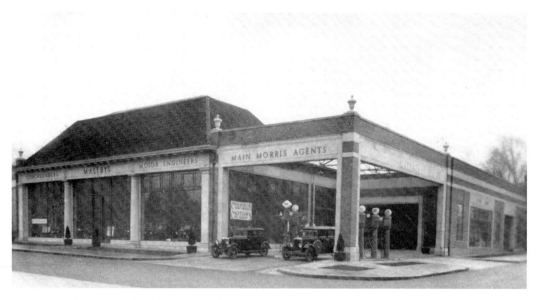

Far grander than any of the other garages shown in this section are the newly-opened (c.1930) premises of Maltby's in New Dover Road, Canterbury. The firm, founded in 1902, is best known for its coach-building activities in Sandgate, but as the reverse of this postcard tells us, they were also Main Agents for Morris in East Kent. Note that there is a glass roof over the petrol pumps, though of course a motorist would, at this date, have remained in his car while an attendant filled his tank. Apart from the inevitable MORRIS Cowley, there is an MG 18/80 on the forecourt.

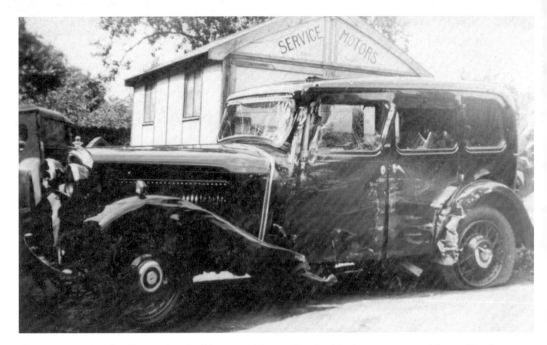

This MORRIS Cowley Six was involved in an accident at Dartford in August 1937 and has suffered considerable nearside damage. It has been removed to Service Motors, Bexleyheath, whose premises seem rather cramped for repair work.

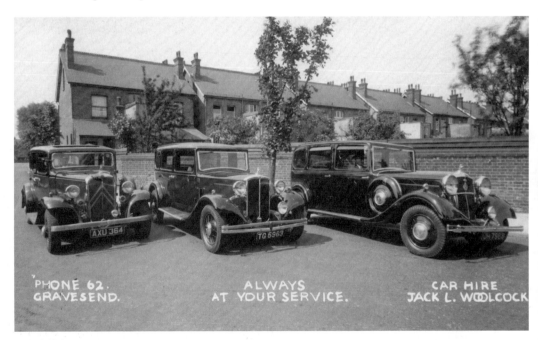

Jack Woolcock of Gravesend has lined up his hire cars across the road for the photographer. One might expect a fleet of big Austins at the period, but he has a CITROEN, a HILLMAN and a WOLSELEY.

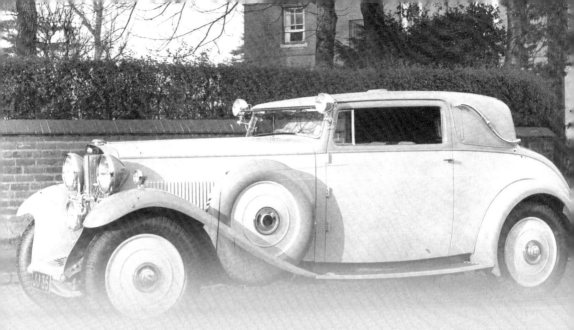

Chapter 7
Kentish Coachbuilders

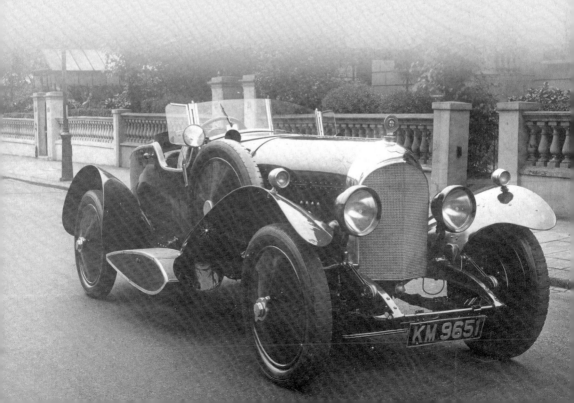

HELY & CO.,
Established Over 100 Years.

Motor Body Builders
. . and Engineers . .

Telephone 0133. Telegrams:—"HELYS, SEVENOAKS."

DESIGNERS & BUILDERS OF HIGH-CLASS CARRIAGES, MOTOR CAR BODIES, CANOPIES & WIND SCREENS.

Sole Makers of THE "PIONEER" CAPE CART HOODS.

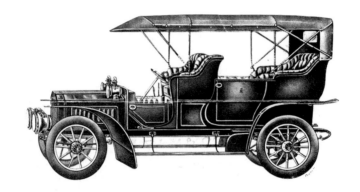

DOUBLE EXTENSION CAPE HOODS FOR SIDE ENTRANCE CARS,
Made DETACHABLE & COLLAPSIBLE also forms DUST SCREEN when folded down.

Delivery Vans for Business Firms a Specialité.

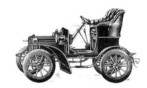

46, London Road, Sevenoaks.

The firm of Hely & Co., of London Road, Sevenoaks, must have been founded around 1800, for this advertising leaflet proclaiming that the business was over 100 years old was issued in 1906. As well as building all types of motor bodies, the company specialised in making "Cape Cart" hoods, as shown in the illustration.

134

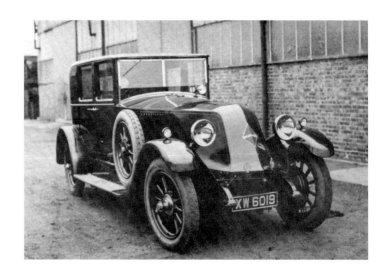

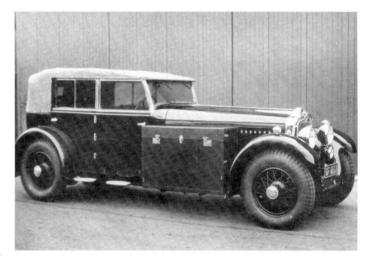

This page: John C. Beadle began bodying car chassis in the nineteenth century, and became a coachbuilder of some significance, exhibiting at London Motor Shows throughout the twenties. The top picture shows a 1925 RENAULT limousine with traditional lines. The lower pictures show cars from *c.* 1930. The MINERVA cabriolet is particularly smart, its clean lines spoilt only by a huge luggage trunk, no doubt specified by the owner, which must have made bonnet access on this side well-nigh impossible. At the bottom is a STAR saloon

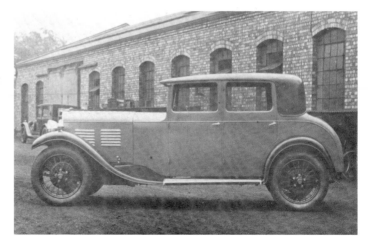

The Beadle name is best known in connection with the bodying of buses; indeed after the Depression the firm concentrated on this area, and continued to do so until well after World War Two. The example shown is on a 1926 DENNIS chassis for W. Buck & Son of Maidstone. Of particular interest is the arrangement of hood and sidescreens, which looks to be reasonably weatherproof, but very claustrophobic.

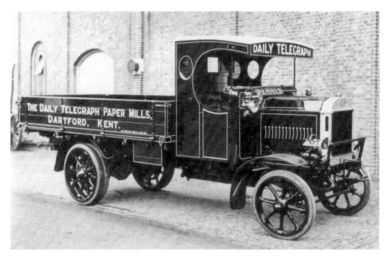

Middle and below:
A competent coachbuilder could turn his hand to any sort of body from a luxury car to a humble van. These two commercials turned out by the Beadle works are a DENNIS lorry for the Daily Telegraph Paper Mills at Aylesford, and a VULCAN van for D. Rees & Co., of Gillingham and Canterbury. The Beadle business is still thriving, though not as coachbuilders.

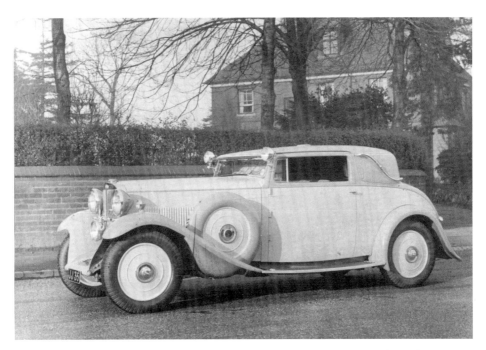

Most prestigious of the many Kent coachbuilders was James Young & Co., of Bromley. Established around 1863 they moved into bodying cars in 1908, and by the time they fitted this SUNBEAM 20 speed model with its fixed head coupe in 1932, they had established a name for quality and style. The very shallow windscreen was a curious styling fad at this time, and the pair of signpost lamps were a useful accessory in the days before Satnav

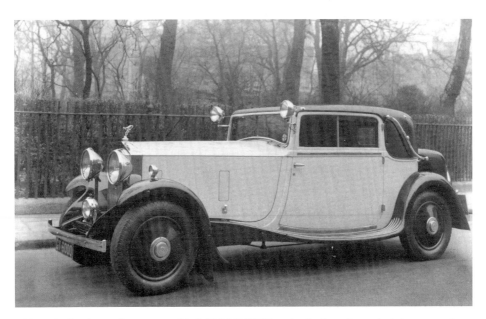

Although also dating from 1932, this ROLLS-ROYCE 20/25 looks quite archaic by comparison with the Sunbeam, but is rather more practical, having far better visibility. On both cars the hood-irons are purely decorative, as the tops did not fold.

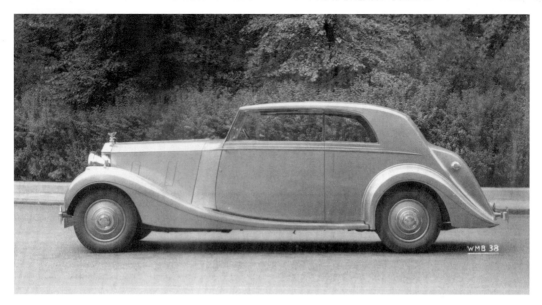

The ROLLS-ROYCE Wraith, introduced just before World War Two, was often bodied with rather heavy formal coachwork, but James Young achieved truly elegant, flowing lines, with very slender windscreen pillars, on this 1939 example. The company ceased to produce bespoke bodies in 1967.

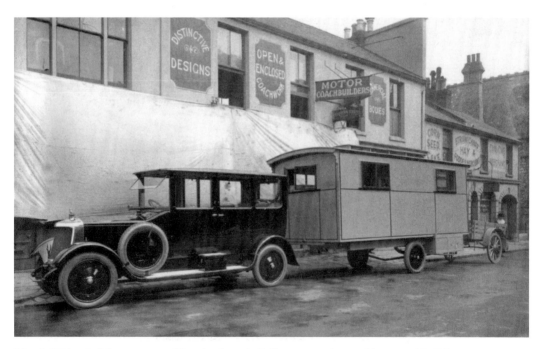

Martin Walter Ltd, began as a saddlery business in Folkestone, and moved into coachbuilding alongside their car-dealing activities. Here we see their premises at that time with a large sheet of rather grubby appearance hung along its frontage so that a photo (in this case of an ARMSTONG-SIDDELEY 30) could be taken without a distracting background. It is unclear how much of this ensemble of car, caravan and trailer is Martin Walter's work.

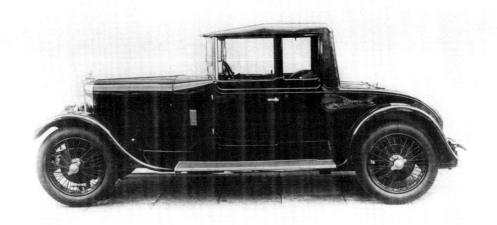

Above and below: Much later, in the twenties, are these examples of TALBOT and ALVIS 12/50 with Martin Walter bodies.

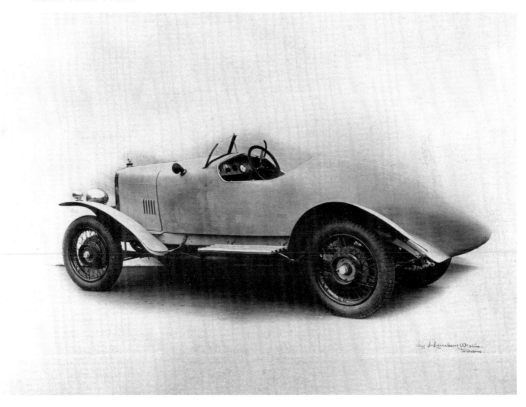

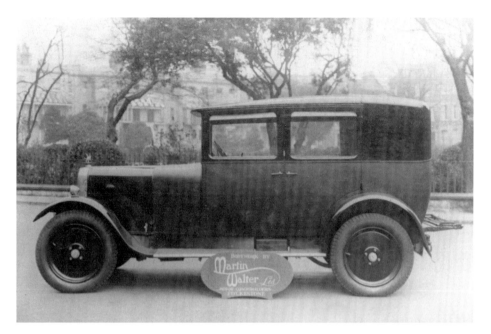

By the mid-twenties, the once prosperous Scottish company of ARGYLL had become a lame
duck, turning out only a trickle of vehicles. It is all the more surprising that someone would
have asked Martin Walter to put this fabric saloon body on an Argyll chassis. The finished
article would not have turned any heads.

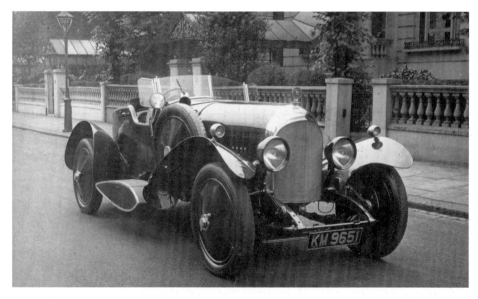

For a provincial coachbuilder, some of Martin Walter's designs were daring and avant-garde.
This 1927 BENTLEY 3 litre is a good example, with its rakish wings, faired in running-boards,
and tapering tail. Wheel discs are surprising on a sports car, but the boat-type air intakes on
the scuttle, enjoyed a brief vogue at this time. The month after this car was delivered to its no
doubt proud owner, Mr Mears, it was stolen in Kensington, and recovered in a damaged state
in Birmingham.

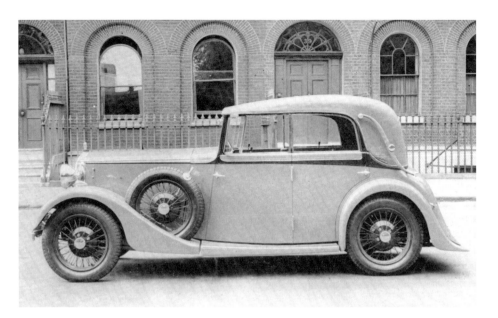

During the thirties Martin Walter specialised in producing cabriolet bodies on chassis such as Vauxhall, Daimler and Lanchester. Two and four door versions were available, known as the "Rye" and the "Wingham" respectively. Above is a DAIMLER 15 "Wingham", and the smooth lines of the hood are immediately apparent. This was due to the German Glaser patent design that Martin Walter used.

In early 2009 the authors received a letter from a man who had bought a plate camera in Rye with which were family negatives – including this one. His question was whether the car photo could help him return the family photos to their owners. The picture showing a newly-coachbuilt Model T FORD landaulette by Neeves & Son of Bapchild, appearing here might just help?

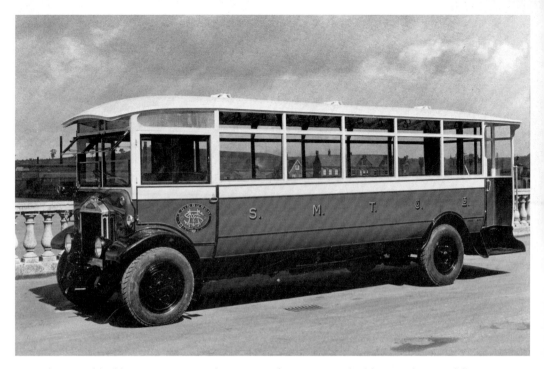

Versatile as coachbuilders were, it was perhaps unique for a company building seaplanes and flying boats to combine this with bodying vehicles, but Short Bros, of Rochester, did just that. Although some car bodies were built (including a surviving one on a sports O.M.) buses were their speciality, such as this MAUDSLAY, one of a batch of twenty-four constructed for Scottish Motor Traction. This was quite an early use of forward control, and the body is notable for its large window area.

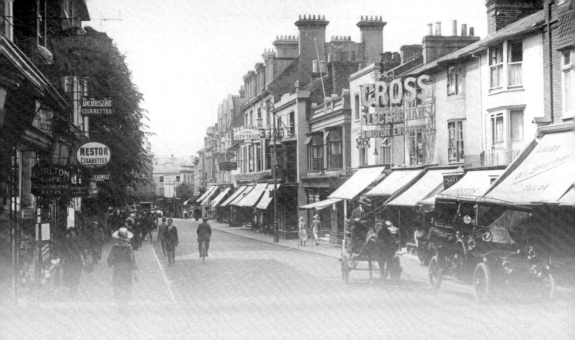

Chapter 8
Street Scenes

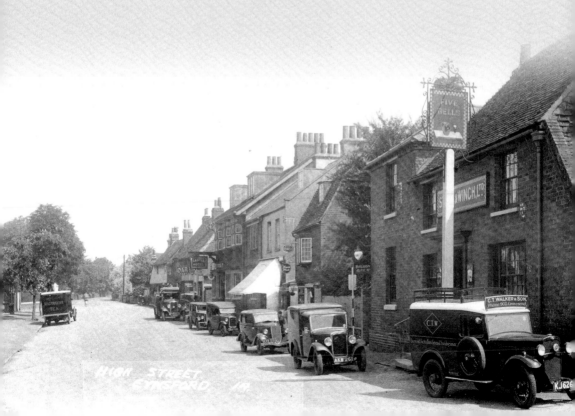

HIGH STREET
STANSFORD

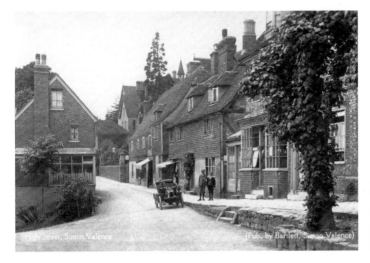

A 1903 Baby PEUGEOT of 5h.p. awaits its owner on a summer day in Sutton Valence. Two smart lads pose for the camera beside it.

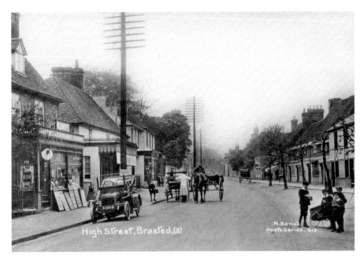

Despite the proximity of the M25, the A25 through Brasted carries a nearly continuous stream of traffic. By contrast when this photo was taken *c.*1910, children could pose for the camera standing in the road. The car is a SWIFT 7/9h.p. belonging to Mr Budgett from Bromley.

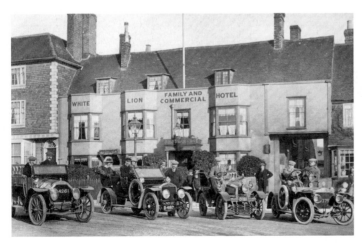

Although this postcard is captioned "White Lion Hotel, Tenterden", the eye is drawn not to the building, but to the line-up of cars. They are, left to right, a 1909 DARRACQ 28/35 of Hubert Igglesden of Ashford,, a 1909 STRAKER SQUIRE 14 of Richard Goose of Gravesend, a 1902 DE DION BOUTON 8 and a 1909 STRAKER SQUIRE 14, both belonging to the de Barri Crawshays of Sevenoaks.

This is the centre of Chelsfield village, near Orpington, and outside the Post Office waits an Edwardian RENAULT Royal Mail van.

Mr Best of Dover owned this smart BELSIZE 14/16 landaulette, seen with its top lowered dominating this scene of Central Parade, Deal.

Above left and middle: It went without saying that Edwardian visitors to high-class hotels could expect garaging for their cars. The Hotel Imperial at Hythe was so proud of its lock-ups that it produced a postcard of them: the cars lined up, with chauffeurs beside them, include DAIMLER, C.G.V., STANDARD, ROLLS-ROYCE and LANCIA. The reverse of the card shows the charges for use of a garage.

POST CARD.

HOTEL IMPERIAL, HYTHE.

ADDRESS ONLY.

AN IDEAL FAMILY HOTEL.

Up-to-Date Garage in Hotel Grounds
(with 8 Lockups),

Heated and Electrically lighted throughout.

WORKSHOP & INSPECTION PITS.
CHAUFFEUR'S SITTING ROOM.

CHARGES FOR CARS.

	Per day.	Per week
General Garage	2/-	10/6
Private Lock-ups	2/6	15/-
Washing and Cleaning Cars	2/6 each.	
Ditto without Brass	2/- ,,	

FREE USE OF PITS, BENCH, VICE, HOSE, & WATER.
Petrol, Mobiloils, &c., Supplied.

Own Golf Links in Hotel Grounds.
PROFESSIONAL SUNDAY PLAY.

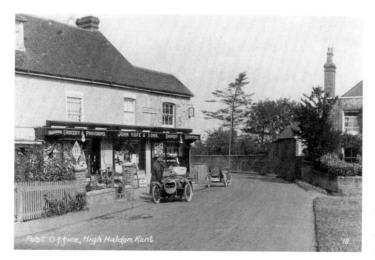

Two of the most basic forms of motor transport were the motor-cycle combination and the three-wheeler, and examples of both are seen outside the stores of John Rofe & Sons in High Halden. This was an ironmongers, grocers, drapers and outfitters, newsagents and Post office combined. The car is a very early example of the famous MORGAN from Malvern.

The High Street in Tunbridge Wells has not changed dramatically in the last 100 years – but the traffic has. Parked by the kerb with the chauffeur relaxing in the front seat is a WOLSELEY 24/30 limousine owned by Edwin Johnston of Burrswood, Groombridge. Burnswood is now a Healing Centre.

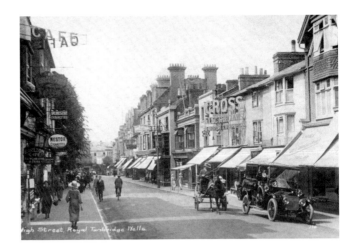

Not strictly a "motoring" picture this record of a serious traction engine accident nevertheless deserves inclusion. The location is Barming Bridge, near Maidstone, the date is 28 April 1914 and the engine involved is thought to be an AVELING & PORTER, belonging to Chittenden & Simmonds, of Malling and Maidstone. The driver was directed to use this road, but apparently did not realise he was about to cross a hopelessly inadequate wooden bridge. (There is now no vehicle crossing here). By great good fortune, all four crew members escaped with their lives.

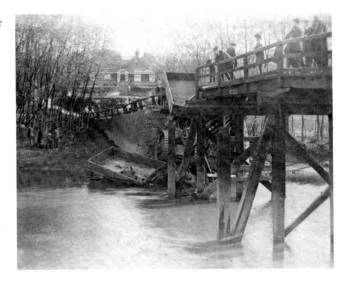

Here is a fine line-up of KARRIER Charabancs drawn up outside the Elephant's Head at Hook Green, with the drivers grouped in front of them. It is fortunate that it is dry, as the 200-plus passengers would have been hard pressed to get inside the pub.

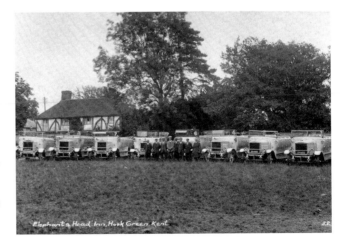

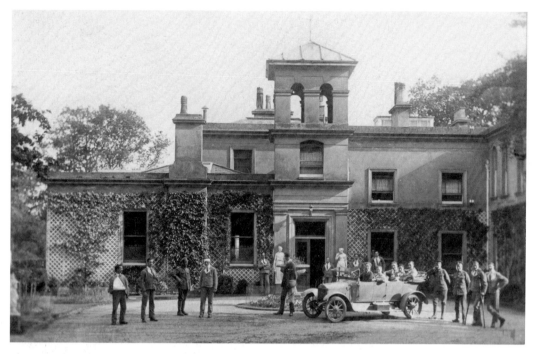

This was an often-photographed sight during World War One; wounded soldiers back from the Front posing outside a makeshift hospital. The car, a 1914 AUSTIN 10, belonged to Miss Julia Stacey of Langton Green.

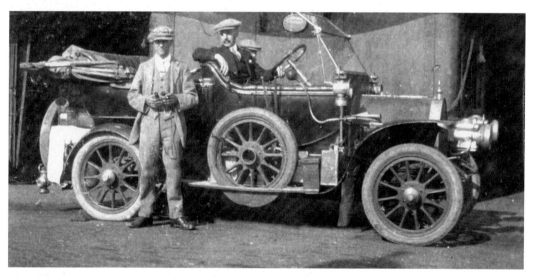

Leaving Gravesend to cross the Thames on board the ferry *Erith* in August 1919 is Mr Mackley's HUMBER 12. The car was well laden for a holiday trip to Scarborough – probably the first for some years.

Having driven his TALBOT-DARRACQ tourer the few miles from his home in Wittersham, Frank Stanford was able to park just where he liked in West Cross, Tenterden.

This light car, seen on the Isle of Sheppey is quite a rarity: a 1922 ERIC CAMPBELL 10.8 two-seater. Its polished aluminium body shows up well. Behind is the inevitable FORD Model T truck. The card is captioned Station Road, Eastchurch, but the railway departed many moons ago.

This is a commercially-produced postcard of the car park at All Hallows on Sea, not the sort of view one would send home to Granny, but perhaps appealing to a car-mad small boy. The number of vehicles is surprising for the 1920s.

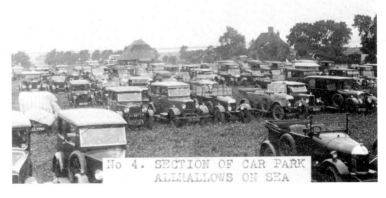

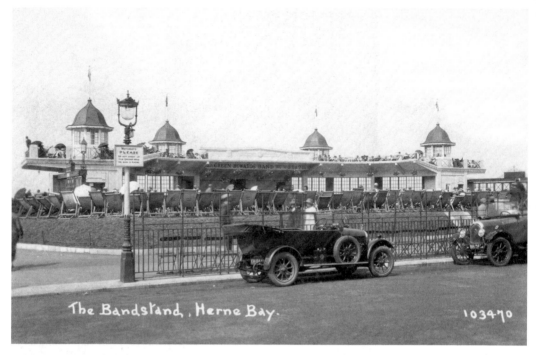

The Bandstand, Herne Bay.

103470

A MORRIS Cowley "Bullnose" and a BEAN face each other behind the bandstand at Herne Bay. Rather quaint is the notice on the lamp post: "Motorists. Please do not start up your engines while the band is playing".

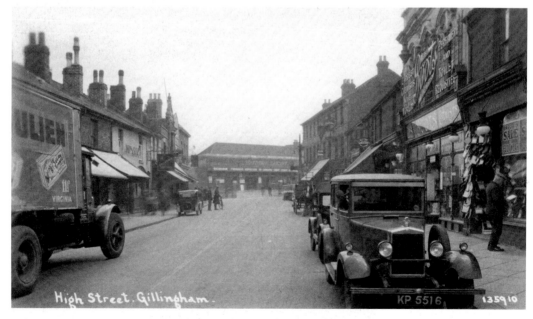

High Street. Gillingham.

KP 5516

135910

This is a typical urban street scene of the early thirties. The location is Gillingham High Street, looking towards the Southern Railway station. Prominent is a MORRIS Cowley saloon, whose owner is perhaps visiting Boots.

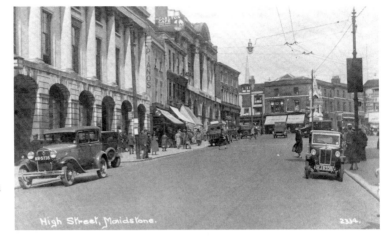

Even in the County Town, traffic seems quite light in this scene from the early thirties. Head on to the camera are (left) a FORD Model A and a MORRIS Minor. The trolleybus wires are evident.

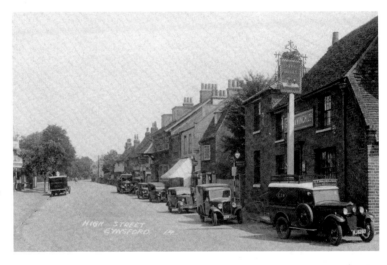

A mixture of cars and light commercials line the main street at Eynsford. The van nearest the camera, owned by C.T. Walker of Gravesend, is a STANDARD 9, never a common chassis for a commercial.

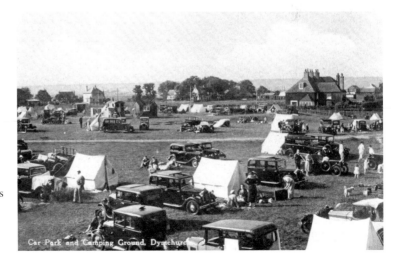

Camping was all the rage between the wars and this car park at Dymchurch doubles up as a camping ground.

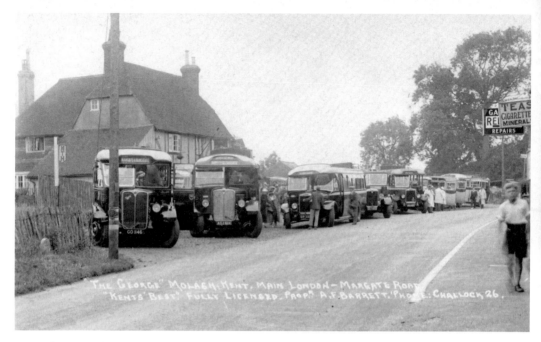

As coach trips to the seaside became the popular way to spend a weekend so stopping-off points for refreshments became important and canny publicans, like that of The George at Molash, cashed in. This line of seven coaches is headed by two A.E.Cs.

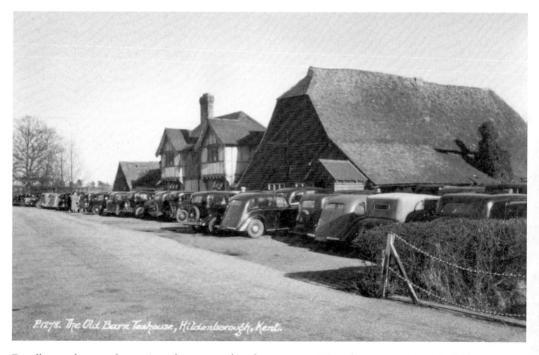

Equally popular was the run into the country for afternoon tea. Where better to go than the Old Barn, near Hildenborough, whose popularity is borne out by the impressive line of cars.

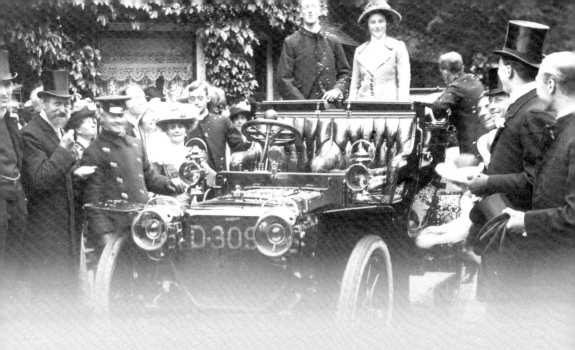

Chapter 9
Public Occasions

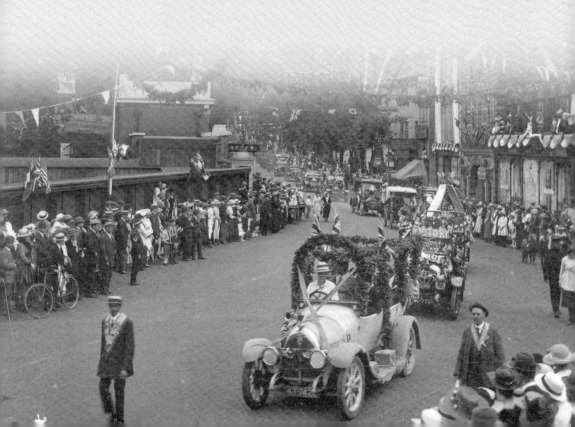

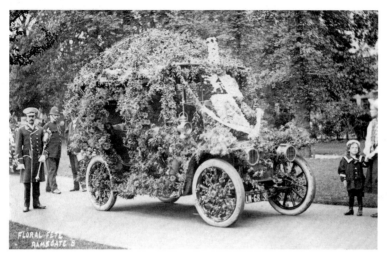

FLORAL FETE
RAMSGATE 8

Above and middle:
These two pictures show cars decorated for the Floral Fete at Ramsgate in 1909. It is hard to imagine anyone going to such trouble today! Note that even the wheels are adorned with flowers and flags. It is unclear whether these were just static exhibits: however there is a chauffeur at the wheel of one, so perhaps not. The authors regret they have not identified the cars!

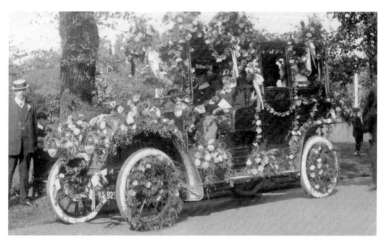

Below left:
The 24h.p. French PANHARD LEVASSOR had an engine of 5,313c. c. in 1908 and this one has a folding cabriolet body. There was no cover over the chauffeur but the uprights for the rear body can be seen folded across the car above the (lowered) glass division. Happily, record of the occasion is also kept. The newlyweds are the Reverend Charles Fleet, curate at Gillingham Parish Church and his bride Dorothy Sharp, daughter of Rear Admiral Sharp of Sutton in Surrey. For going away "the bride wore a travelling costume of *miel fonce* cloth with a hat to match of hatter's plush trimmed with autumn berries." The wedding was in April 1913.

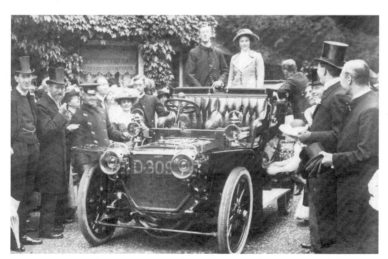

This snowy scene was photographed on 17 March 1909 in Pembury and the resulting postcard was sent just six days later. It shows spectators awaiting the arrival of cars taking part in the "Guards' Dash" from London to Hastings organised by the A.A., which set out to show the practicality of transporting troops by motor car and was rated a success. The parked cars, not participants, are headed by a ROVER and a DARRACQ, and the number of onlookers is worthy of note!

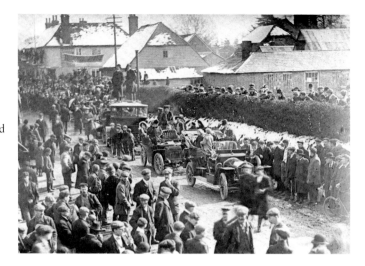

A ROVER 15h.p. landaulette of 1911 is shown overtaking a pipe band of the Seaforth Highlanders at Shorncliffe Camp.

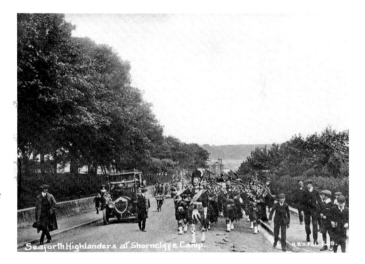

When the Duchess of Albany paid a visit to Chislehurst on 24 May 1913, she was conveyed in this splendid, nearly-new ROLLS-ROYCE 40/50 Silver Ghost landaulette, with coachwork by Thrupp & Maberly, and owned by Sir George Chubb who is seated beside the chauffeur (whose name was Goff!). The following car is a Talbot.

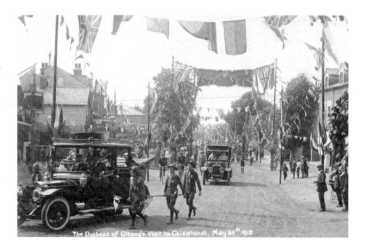

155

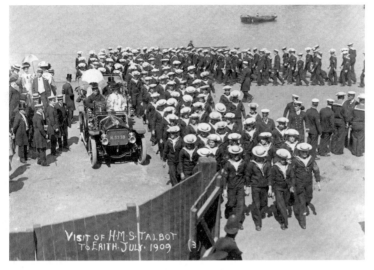

Visit of H.M.S. Talbot to Erith. July. 1909 (3)

HMS *Talbot* paid a visit to Erith in July 1909, and this postcard shows the crew marching ashore, while dignitaries are conveyed in a WOLSELEY-SIDDELEY tourer. The message reads "Can you see me in this one? – Harry"

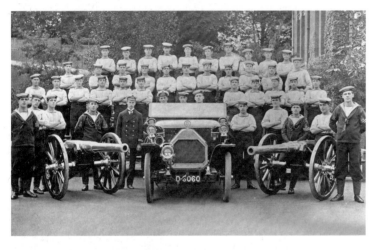

Another photo with a nautical flavour shows ratings from HMS *Pembroke* lined up behind a BELSIZE 14/16h.p. two-seater at Chatham. The car belonged to Captain H.R. Lever of Rochester.

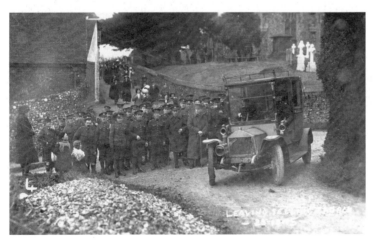

It has not been possible to identify the reason for the publication of this postcard. The location is Selling Church, the date 29 December 1915, and the car a Wolverhampton-built BRITON. The large military presence might have suggested a funeral, but a close inspection suggests this is unlikely.

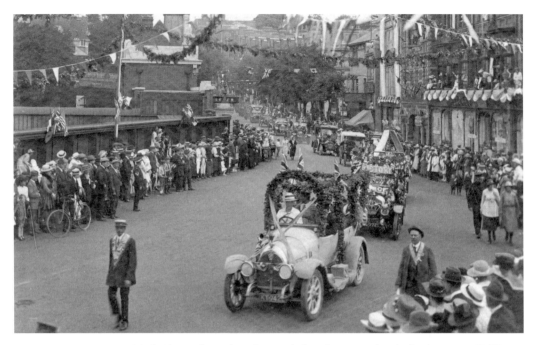

Peace Day 1919 in Tunbridge Wells, and as if to symbolize the new order, the leading car, a FIAT 15/20 tourer, carrying wounded soldiers, is driven by a lady. She is Miss Ross of Chancellor House, Tunbridge Wells.

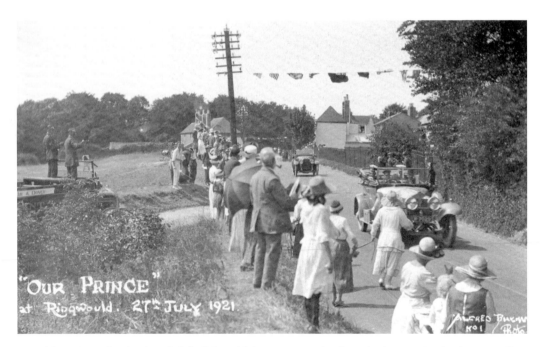

The Prince of Wales, later briefly Edward VIII, was a popular figure in the twenties, having cast off much of the stuffiness (and some of the dignity) of older Royalty. Here he passes through the village of Ringwould on an official visit to Kent, in a ROLLS-ROYCE Silver Ghost. The date is 27 July 1921.

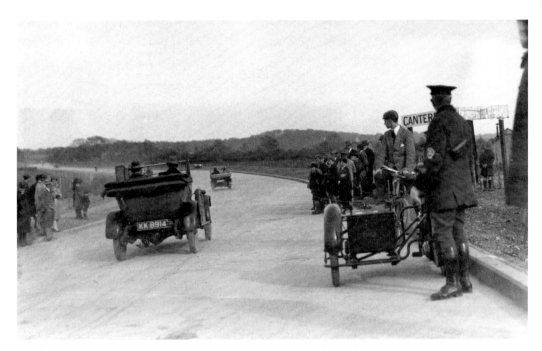

Above and below: By-passes were all the rage between the wars, and necessarily so with the increase in traffic. Taken 3 March 1926, these pictures show the opening of a new section of the A252 to by-pass Charing village. In the upper picture an R.A.C. Scout features prominently as a MORRIS Cowley sets off along the new stretch of road; below an ESSEX and SUNBEAM face the camera, as a number of onlookers display the fashionable plus-fours.

A large THORNYCROFT, registered in East Sussex is undaunted by the flood water outside Tunbridge Wells station.

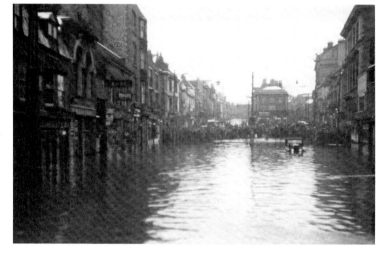

The date here is 1927, and the location easily recognisable as Maidstone High Street. A brave, or more probably foolhardy soul in a BELSIZE-BRADSHAW light car is attempting to ford the waters; a large crowd is enjoying the tension.

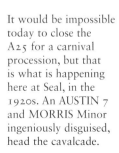

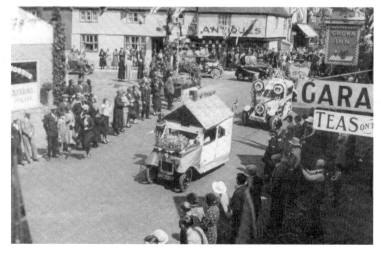

It would be impossible today to close the A25 for a carnival procession, but that is what is happening here at Seal, in the 1920s. An AUSTIN 7 and MORRIS Minor ingeniously disguised, head the cavalcade.

Acknowledgements

Les Burberry of the Road Locomotive Society
Tom Clarke
Alan Cross
Bruce Dowell
Robert Grieves
David Hales
Malcolm Jeal
Alan Lambert for his help with the bus section
Richard Mitchell
Geoffrey Morris
Richard Peskett for use of the Beadle pictures.
The Royal Commission on Historical Documents (England)
Cedric Verdon
Nick Walker for information about coachbuilders.
Michael Worthington Williams

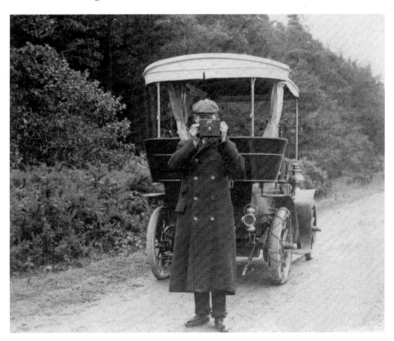

We hope that this pioneer motorist and photographer may be allowed to represent all those unknown photographers of long ago whose pictures have permitted us all to enjoy the pictures in this book.

We wish we could acknowledge them more personally.
Tim Harding and Bryan Goodman